THE GALLERY OF
WEST BOHEMIA
IN PILSEN

T0010538

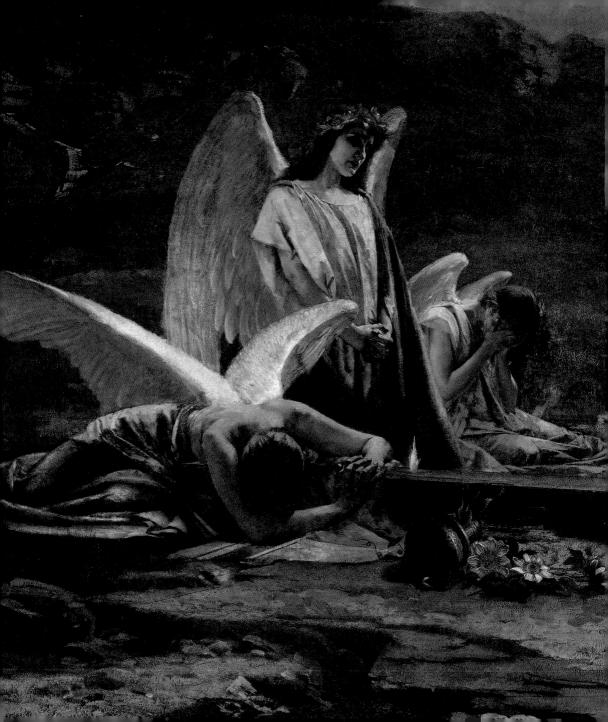

50 MASTERPIECES OF CZECH FIN DE SIÈCLE ART

FROM THE COLLECTIONS OF THE GALLERY OF WEST BOHEMIA IN PILSEN

SCALA

THE TURN OF THE CENTURY

The period at the turn of the twentieth century has always been understood as a break between epochs, and this was similarly the case in the visual arts. Modern art was emerging and being promoted, but the artistic scene itself was diverse and open to different concepts. From the mid-nineteenth century onwards, the popularity of paintings grew enormously, supported by the new technology of mass reproduction of their facsimiles. A typical example is the poster, which transformed from a written notice into a popular form of pictorial advertising. The 'salon of the street', then, attracted the public not only to all kinds of entertainment, but also to annual Salons where paintings and sculptures by contemporary artists were shown by the thousands. The Salons were originally organised by the state, and later by local art associations, responding to the remarkable growth of the art trade. An artist who was accepted into the show and judged favourably by journalistic art critics could win awards, fame and substantial earnings at the shows. The struggle for a financially sound art lover and patron ensued.

In the 1890s, the situation was already so obfuscated that it was difficult, for young artists in particular, to make themselves visible. It was even more difficult for the public to find its way around the mass of products on offer. Some sort of order and organisation had to be imposed, which manifested itself in terms of the institutions. In 1890, the new Societé nationale des Beaux Arts (National Society of Fine Arts) broke away from the general association of French artists, and this 'secession' became the signal for similar events to take place in Munich, Vienna and Berlin.

Prague did not stand aside either. Already in the 1880s, young painters, dissatisfied with the standards of teaching at the local Academy of Fine Arts, left Prague for Munich. There they founded their own association, Škréta, named after the famous Czech Baroque painter and exile Karel Škréta (1610–1674). From there, they soon headed to Paris, which became a permanent source of their enlightenment.

In the mid-1890s, the student union Mánes came to life in Prague. It began publishing its own magazine titled *Volné směry (Free Trends)*, and in 1898 it started an exhibition activity that became the most important source of modernism in Czech culture in the following years. In 1902, the union organised a retrospective exhibition of Auguste Rodin's (1840–1917)

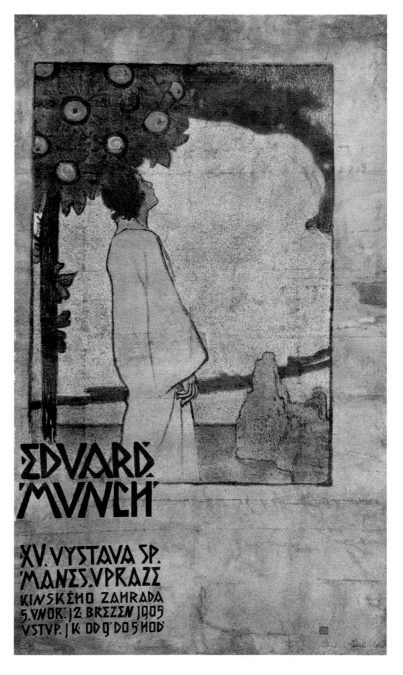

Jan Preisler, a poster for
Edvard Munch's exhibition
in Prague, 1905, Museum of
Decorative Arts in Prague

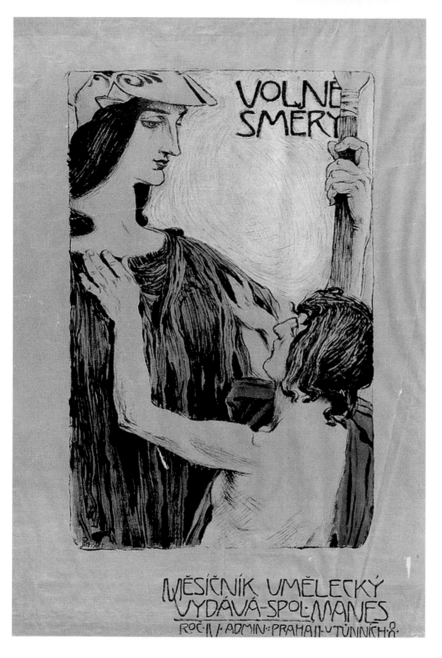

Jan Preisler, a poster for
Volné směry (Free Trends)
magazine, 1899,
Alamy Stock Photo

œuvre and an exhibition of French painting. This was followed by the Worpswede School, Edvard Munch (1863–1944) in 1905 and the Independents in 1910, paving the way to the reception of cubism.

These activities, however, took place against the backdrop of a diverse scene, in which modern views on the picture and painting were entering the cultural practice of artists and the consciousness of viewers. In doing so, generations often overlapped and mixed and, in addition to the traditional Krasoumná jednota (Fine Arts Society) and Spolek výtvarných umělců Mánes (Mánes Union of Visual Artists), other artistic associations and institutions were created. The favourable economic development in the Lands of the Bohemian Crown also allowed for funds to be made available for the representative urban development of towns and the artistic decoration of their landmarks, and for members of the wider bourgeoisie to invest in the visual arts for their own use, too.

Individuality of artistic expression became particularly valued in art, which encouraged a diversity of tastes. Leading art critics, such as František Xaver Šalda (1867–1937), called for a new style that would express the unity of art and modern life, and inspirations of decorative art nouveau, symbolism and impressionism made their way from Paris to Prague.

Modernity asserted itself both thematically and formally. The interest in traditional painting of historical and classical mythological scenes was leaving the stage in favour of observations of everyday life and the domestic landscape. Luděk Marold's (1865–1898) skilful 'reports' from bourgeois boudoirs and folk entertainments and festivals, as well as Miloš Jiránek's (1875–1911) zest for sport as a striking phenomenon of modern life, were witnesses to a new empiricism. Instead of traditional anecdotes and genre stories, audiences began to be attracted to this spectacle, promoted by the multi-coloured posters of the 'salon of the street'. The persistence of the visual experience brought down the walls between the interior and outside world and, to top it all off, the tourist experience of travelling to foreign countries was underway.

The art of the time, however, also testifies to a morally traditional view of the public. The Church modernised its sanctuaries with new decorations of original stained-glass windows, but also in sacred art, personalities such as the sculptor František Bílek (1872–1941) began to emerge, who put their own personal religious experience first.

Jan Preisler (1872–1918), *c.* 1905,
Archives of the National Gallery in Prague

The need to satisfy the imaginative inclinations of the viewer did not die down either. The audience's imagination was saturated with the then favourite funeral themes, ranging from historical reminiscences and legends to graveyard visions. The art nouveau period loved the heroes and monsters of fairy tales. Two approaches soon emerged in this direction: one still distinctly romantic, with a penchant for mysterious scenery, colourful effects and archetypal characters; the other closer to the grotesque, taking a personal, ironic look upon the world.

Czech 'secessionists' were particularly successful within the latter group. A sense of humour had not been alien to some of the unconventional academics and professors: Maxmilián Pirner (1854–1924) ridiculed his academic opponent as the 'Frog King'; Hanuš Schwaiger (1854–1912) introduced social issues to the world of fantasy through the figure of the Pied Piper; Jaroslav Panuška (1872–1952) linked nature and the afterlife in a spiritistic way; and the pinnacle of this trend was the frenetic visions of Josef Váchal (1884–1969), who depicted the world in an expressionistic manner as a playground for ghosts.

From there, it was not a long way to real socially critical work. Thus, at the beginning of the twentieth century, František Kupka (1871–1957), the future famous abstractionist, in his cycles drawn for French anarchist magazines, sharply attacked the profiteering capitalism that controlled politics and the masses of workers through its corruption. And no wonder – even poetically oriented artists showed interest in depicting working people.

The dualism of contemporary taste, which professed both naturalism and symbolism, gradually pushed for a synthesis of ideas in art. Initially, impressionism was used for this, even understood as a new view of the modern world. The painters who followed this path, however, soon encountered the limits of visual mimesis.

At the same time, the new visuality (accentuating and enhancing visual perception of the real world through artistic means) directed attention to themes that were originally strongly ideological. Thus, realistic folklorism (represented, for example, by Václav Malý (1874–1935)) came into being, although it tended to only exploit the potential of modernity. It was Jan Preisler (1872–1918), in his triptych *Jaro (Spring)* from 1900, who was able to transform this domestic theme into a modern image. Artistically, this meant applying the post-impressionist concept of colour and

plane decorative composition. Preisler became the main representative of Czech art nouveau painting by the way he stylistically integrated the new sensuality with emotionality and created their synthesis in generous decorative painting. His vibrant use of colours directly conveyed the deep psychological message of liberating melancholy.

Landscape painting was of great importance in Czech visual arts, which switched from the fashionable Alpine landscapes to a greater experience of the domestic landscape at the end of the nineteenth century. The so-called Mařák School became especially famous, named after the popular professor of landscape painting at the Academy of Fine Arts, Julius Mařák (1839–1899). The common approach was characterised as 'ambience landscape painting', immersed in depicting intimate nooks and outlines of the countryside. The key personality here was Antonín Slavíček (1870–1910), who, during his summer stays in the Bohemian-Moravian Highlands in 1903–05, produced works that are still considered typical depictions of the Czech landscape. They had the persuasiveness of *plein air* paintings, but also their own natural symbolism, usually in the form of a dirt road rising to a stretched horizon, reminiscent of the age-old work of rural people. A large part of Slavíček's œuvre was likewise devoted to his native city of Prague, where his energetic brushstroke captured the pathos of the old city and the flow of its inhabitants.

Both Preisler and Slavíček were members of Mánes, which persistently promoted the idea of modern art. They were soon followed by the younger generation which, as early as around 1910, was moving towards avant-garde cubism.

In the short period of time before the First World War, various artistic trends manifested themselves in the Czech arts scene, which testified to its vitality. Members of the first art nouveau generation also made their voices heard. In 1910, Alfons Mucha (1860–1939), a veteran of the modernism of the 1890s, returned to his homeland from the United States. Burdened with ideological load, his *Slovanská epopej (Slav Epic)* stirred up controversy and was rejected as an anachronism, as the avant-garde had yet to reach its peak. But, like many other of his peers, he left a trail that leads to the enduring question on the mission of modern art.

Petr Wittlich

ART OF THE FIN DE SIÈCLE IN THE COLLECTIONS OF THE GALLERY OF WEST BOHEMIA IN PILSEN

The period of the turn of the twentieth century was one of the most turbulent and dynamic stages in the development of fine art, which was becoming an increasingly important part of life in continental Europe and elsewhere at that time. The *belle époque*, as the period from the 1890s to the beginning of the First World War is retrospectively referred to, provided generous room for the establishment of artistic movements and trends such as symbolism, art nouveau and impressionism, which originated mainly in France but soon gained international significance. Artists began to explore new themes for their work that reflected the contemporary atmosphere in society, from the weariness and scepticism of the end of the century to the belief in the social progress that the coming new age would hopefully bring. Among these moods, unconventional interpretations of religion, spiritualism and esotericism, fairy tales and fantasies played a key role; but it also reflected social criticism of society, labour, the countryside and its folklore, the modern way of life in the city, the new possibilities for leisure offered by sports, etc. Among the painting genres, landscape painting was becoming a privileged discipline that responded to many of these stimuli and was strongly influenced by the aforementioned symbolism, art nouveau and impressionism. It was at this time that a new wave of emancipation of Czech art began to rise, which worked hard to integrate more strongly into international structures.

The collection of Czech art of the fin de siècle period in Západočeská galerie v Plzni (the Gallery of West Bohemia in Pilsen, GWB) is, both in terms of the quantity and the quality, one of the best – not only within the collection of the gallery but undoubtedly also in the context of public collections in the Czech Republic. It is worth noting that art of the period in question had been prominently represented in the collections of institutions that had existed in the region before the founding of the GWB in 1954, such as Západočeské umělecko-průmyslové museum v Plzni (the Museum of Decorative Art of West Bohemia in Pilsen), Plzeňská městská obrazárna (Pilsen Municipal Art Gallery) and Plzeňská banka (the Bank

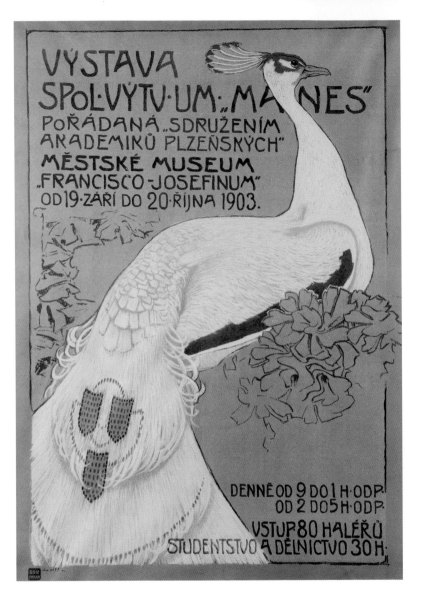

Jan Preisler, a poster for the exhibition of Spolek výtvarných umělců Mánes (Mánes Union of Visual Artists) in Pilsen, 1903, Museum of West Bohemia in Pilsen

of Pilsen). From there it was subsequently transferred to our gallery and formed an important basis for, among other things, the collection of art from the turn of the twentieth century. A special role was played by the National Gallery in Prague, which gradually transferred to the newly established regional galleries from its collections some of the works of those artists who were related to the respective region. This applied to the art collections that came from liquidated organisations, too; in the case of Pilsen, this was primarily Plzeňská banka, which was dissolved in 1948 and whose artworks were first deposited in the collections of the National Gallery in Prague, but after the establishment of the GWB were transferred to the collection of the latter. The collection of Czech art of the fin de siècle period subsequently expanded over a long period of time and is now an integral part of the gallery's acquisition programme. Purchases from antique shops, antique dealers and private collectors have been the source of its new acquisitions; in the period following the Velvet Revolution of 1989, acquisitions from auction galleries have been added, and there are many donations and bequests from estates as well.

The large collection of Czech art of the fin de siècle in the GWB includes all the important artists who were active on the art scene of the time; however, the most interesting collections from that period in terms of number and quality belong to Alfons Mucha, Jan Preisler, Antonín Slavíček, Václav Brožík (1851–1901), Jaroslav Špillar (1869–1917), Maxmilián Pirner and Josef Mandl (1874–1933). In the case of drawings, some artists, such as Mucha and Preisler, are represented by generous colour drawings in pastel, chalk or watercolour. At the same time, the collection of the GWB includes several works that had a clear programmatic character at the time of their creation, articulating the trends for the further development of the domestic art scene, while considering the international context. Very soon it became an integral part of the Czech history of art, in which it occupied a dominant position. These undoubtedly include the works of two leading figures of the time – the triptych *Jaro (Spring)* by Jan Preisler from 1900, which became a key work of Czech art nouveau, and Antonín Slavíček's paintings, especially those from his 'Kameničky' period (e.g. *Silnice / Krajina z Kameniček [The Road / Kameničky Scenery]* from 1903–04), which heralded (and by no means only in landscape painting) the emergence of modern Czech art of the twentieth century.

One of the extraordinary acquisitions our gallery has been able to purchase is undoubtedly the numerous drawings by František Kupka from his famous series *Peníze (L'Argent, Money)* from 1901 (nineteen sheets in total), which were purchased for the GWB's collection in 1971 from the collection of Adolf Hoffmeister (1902–1973) – a personality of extraordinary universal talent, which he exercised in the field of art, law and diplomacy in the interwar and post-war periods in Czechoslovakia. Another of Kupka's drawings from 1901, *Ukřižovaný dělník (A Worker Crucified)*, purchased by our gallery a year later, comes from the same source. Hoffmeister, who had close personal relations with the artistic milieu of Paris, where he served as the Czechoslovak ambassador after the Second World War, met Kupka in person and very likely acquired the above-mentioned set directly from the artist. For the GWB, this exceptional acquisition therefore has added value thanks to its original owner, and in the future, it may be an interesting contribution to the history of art-collecting in the former Czechoslovakia.

The collection of Czech fin de siècle art at the GWB includes some works with religious themes. It is interesting to see how they became part of our collection and whether any objections were raised against them by the purchasing committee, which (at least through some of its members) was tasked with overseeing the ideological soundness of the new acquisitions. In the compulsory atheistic environment of socialist realism (1948–89), where, for over forty years, the cultural policy of the state was subject to Communist ideology, it was not always easy to acquire objects with religious content for the gallery collections. In the case of the GWB, such a case occurred after the mid-1970s, when the then purchasing committee refused to purchase Jan Zrzavý's (1890–1977) 1963 pastel drawing *Hlava Krista (The Head of Christ)*; however, by a happy coincidence, it was acquired for our collections in 1994 after the Velvet Revolution. In the case of religiously-oriented art from the turn of the twentieth century, the artists in question were no longer living, and their respective works were mostly administratively transferred to the GWB's collection from other institutions during its establishment or shortly thereafter (i.e. without being discussed by the purchasing committee). In other cases, such as that of Josef Mandl, a renowned native son of Pilsen, a greater degree of tolerance was shown towards some works by the ideological apparatus.

Antonín Slavíček (1870–1910), *c.* 1900,
Archives of the National Gallery in Prague

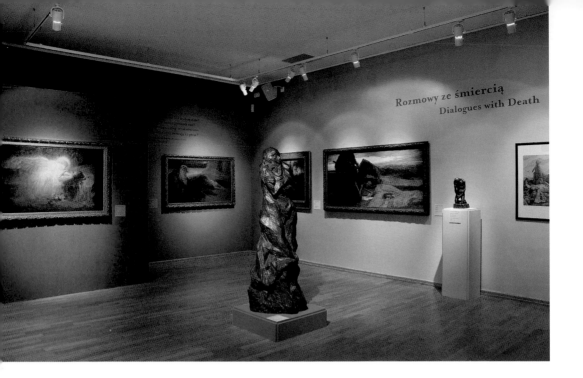

Rozmowy ze śmiercią
Dialogues with Death

The quality of our collection of Czech art of the fin de siècle is also demonstrated by the fact that its individual works are repeatedly loaned to important foreign exhibitions and their reproductions are an integral part of the accompanying publications. Works from our collection thus help to complete the canon of European art history of the time, of which they have always been an integral part. Among the important exhibition and publication projects carried out in the framework of international cooperation after the Velvet Revolution, the following examples included works from our collection: *Lost Paradise: Symbolist Europe* (The Montreal Museum of Fine Arts, 1995); *In Commemoration of the 150th Memorial Birth 'Alphonse Mucha'* (Takasaki Museum of Art & Takasaki Tower Museum of Art, 2010); *Images of the Mind: Bildwelten des Geistes aus Kunst und Wissenschaft* (Deutsches Hygiene-Museum Dresden, 2011–12); *Secesia:*

The exhibition *Masters of Dreams*, Krakow, 2014; a view of the part with artworks loaned by the Gallery of West Bohemia in Pilsen. Exhibition design by Monika Bielak & Malwina Antoniszczak

umelecké poklady (Galéria mesta Bratislavy, 2013); *Decadence: Aspects of Austrian Symbolism* (Belvedere Vienna, 2013); *Władcy snów: symbolizm na ziemiach czeskich 1880–1914* (Galerija Międzynarodowego Centrum Kultury w Krakowie, 2014); *Sterne Fallen. Von Boccioni bis Schiele. Der Erste Weltkrieg als Ende Europäischer Künstlerwege* (Kunsthalle zu Kiel, 2014–15); *The First Golden Age: Painting in the Austro-Hungarian Monarchy and the Műcsarnok* (Műcsarnok, Budapest, 2016–17); *Klimt ist nicht das Ende. Aufbruch in Mitteleuropa* (Belvedere Vienna, 2018); *Beyond Klimt: New Horizons in Central Europe* (BOZAR, Centre for Fine Arts, Brussels, 2019); *Phantome der Nacht. 100 Jahre 'Nosferatu'* (Nationalgalerie Staatliche Museen zu Berlin, 2022–23).

The representation of Czech art of the fin de siècle in the collection of the GWB is far more extensive than the selection of the fifty masterpieces that we are presenting in this book, published in collaboration with Scala Arts & Heritage Publishers. It is an important part of our broader collection and, in the future it will certainly form one of the essential parts of the permanent exhibition we are preparing with the planned building of a new gallery. As part of the exhibition and editorial programme, individual works from this collection are continuously included in thematic and monographic exhibitions, allowing them to be evaluated in different contexts in accompanying publications. The GWB is the only regional gallery in the Czech Republic that has the status of a research institution granted by the Council for Research, Development and Innovation of the Government of the Czech Republic, and as part of its scientific activities it focuses its systematic research on art originating from the turn of the twentieth century. Recently it has been concentrating on the provenance research and on how the works of this period were reflected in the development of acquisition strategies and exhibition programmes against the background of cultural, historical and political events and the ideology of the time. All of this has provided us with a broad scope of material and experience during the creation of this publication, which thus has a clear transition from popular non-fiction writing intended for the public towards a scholarly assessment of our long-standing work.

Roman Musil
Director of the Gallery of West Bohemia in Pilsen

VOJTĚCH HYNAIS

(Vienna 1854–1925 Prague)

Design for a poster for the 1891 General Centennial Land Exhibition in Prague, 1890

Oil on canvas, 195 × 125 cm

Inv. no. O 79

Acquired in 1954

In 1891, the General Centennial Land Exhibition, known as the Jubilee Exhibition, was held in Prague. One of the largest exhibitions held in the Czech lands in the nineteenth century, it presented products from the fields of industry, technology and agriculture at the newly established exhibition grounds in Prague's Stromovka Park. It was accompanied by a comprehensive exhibition of fine art, representing the development of domestic art over the preceding hundred years. The Paris-based Czech painter Vojtěch Hynais, who was commissioned to design a poster for the exhibition, based his design on the allegorical figure of the motherland (Czechia). The figure depicts a young girl hovering above the silhouette of Prague Castle, holding a lime branch (the Czech national symbol). The cupid by her head is holding a laurel wreath, intended for Czechia's coronation, which bears the initials of Emperor Francis Joseph I, under whose auspices the exhibition was held. Other symbols in the painting – such as a lion (both live and stylised), palm branches and ancient columns – refer to the Kingdom of Bohemia. At the same time, they express the noble mission and importance of the exhibition, which was to acknowledge the Czech lands as an integral part of Europe. The painting is still without the exhibition and other Czech-German texts, which appear only on the final poster, printed the following year by means of chromolithography. The model for the figure of the motherland was the later renowned French painter Suzanne Valadon. Hynais's somewhat conservative and academic concept of the poster, although it is a soaring and elegant painting, still refers to the ideals of the community of artists known as the 'National Theatre Generation'. Hynais also expressed them in his design for the theatre's ceremonial curtain, where he also depicted a levitating female figure as an allegory of genius (or Czechia), even using the same model. Although this is one of the earliest Czech artistic posters, the main era of the new artistic medium only came with the advent of art nouveau in around 1900, as represented by Alfons Mucha. RM

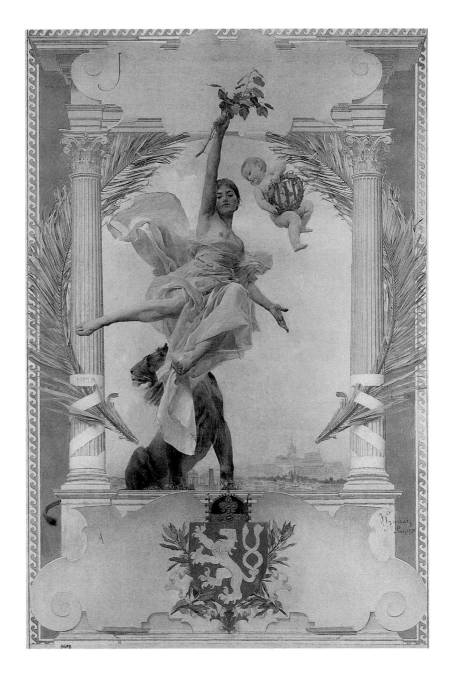

BENEŠ KNÜPFER

(Frýdštejn 1844–1910 the Adriatic Sea, between Rijeka and Ancona)

Ponte Margherita Embankment, AFTER 1900

Oil on canvas, 45 × 58 cm

Inv. č. DO 8

Acquired in 1954

Beneš Knüpfer acquired an exceptional position in Czech art. He gained a European reputation as a painter of the sea, which earned him a mark of exoticism in landlocked Bohemia. For a long time, he was not well known here; after studying in Prague and Munich, he settled permanently in Rome, where he set up a studio in the tower of the Palazzo Venezia, the seat of the Austro-Hungarian embassy. He was very popular with collectors and extremely successful in the 1880s and 1890s. His canvases, often large, attracted attention with views of sunny seashores, sparkling surf and nymphs frolicking among the waves. His fondness for depicting aquatic creatures from ancient mythology invites comparison with the thematically similar works of the Swiss painter Arnold Böcklin. Landscapes and portraits were a peripheral concern in Knüpfer's work. It was only in his late period after 1900 that he created several interesting urban genre paintings, including the pictured canvas. It depicts the Tiber embankment in Rome in the pinkish light of the setting sun; pedestrians stroll, and children play in this early evening atmosphere. The viewer seems to be watching the scene through the eyes of a man in a hat leaning against a railing in the foreground. After 1900, the great demand for his works led Knüpfler to repeat and replicate earlier works. From the 1890s onwards, he sent paintings to exhibitions in Prague and established a studio there. Unfortunately, his exhibitions, which mainly featured his later work, did not meet with success and he was mercilessly criticised by the younger generation of artists. Apparently under the sway of the unsuccessful exhibition in 1910, he sold his works below the market price, made his will and left for Italy. On a boat crossing from Rijeka to Ancona, he symbolically ended his life by diving off the boat. After Knüpfer's tragic death, his paintings were in great demand and no bourgeois salon was complete without them. *Ponte Margherita Embankment* was originally held in a private collection in Pilsen; from there, it was bequeathed first to the Pilsen Municipal Art Gallery and later transferred to the collections of the Gallery of West Bohemia. IS

VÁCLAV BROŽÍK

(Třemošná, near Pilsen 1851–1901 Paris)

Red Interior (Sedlmeyer's Interior in Paris), 1893

Oil on canvas, 38 × 44 cm

Inv. no. O 393

Acquired in 1962

The famous Czech painter of historical themes and later landscape and genre painter Václav Brožík went through truly prestigious training: after Prague, Dresden and Munich (under Karl von Piloty), he settled in 1876 in Paris, where he began to send his works to the Paris Salons with increasing success. In 1878, he drew attention to himself with a monumental painting featuring a scene taken from Czech-French relations, *The Wedding Delegation of King Ladislaus of Bohemia and Hungary to the French Court of Charles VII*. It was purchased by the Parisian picture dealer Charles Sedelmeyer. In addition to Sedelmeyer's interest in the Old Dutch masters, the influential gallerist contracted Brožík and many other Austro-Hungarian painters. Brožík confirmed that he belonged to Sedelmeyer's circle in 1879 by marrying the gallery owner's daughter Hermine. Sedelmeyer skilfully arranged exhibitions of 'his' artists not only in Paris and Central Europe, but also introduced their works to the international art market. That also applied to Brožík, who received numerous official honours: in 1893, he was appointed professor at the Prague Academy and knighted, and in 1896, he became a foreign member of the French Académie des Beaux-Arts. Sedelmeyer made his mark on the Parisian art scene with exhibitions at his gallery in rue de la Rochefoucault. Brožík likewise presented some of his large-scale historical paintings there. Before departing for Prague in 1893, he captured in two paintings the salon rooms in his father-in-law's dwelling adjacent to the gallery. These works are intimately programmatic: the painter seems to be demonstrating in them his ability for old-master succinctness. In *Red Interior*, Brožík concentrated on the expressive device of contrasting complementary colours – red and green – updated by Delacroix and again emphasised in Brožík's time. Interiors without figurative staging or conversational scenes (which, similarly, were part of Brožík's repertoire) became established as a specific genre. Here, Brožík masterfully rendered the atmosphere of an art-lover's dwelling full of artworks and objects which, however, are only hinted at, making the painting only a brief glimpse into a home salon. MT

Luděk Marold

(Prague 1865–1898 Prague)

In the Boudoir, 1896

Watercolour and pencil on paper, 36 × 30 cm

Inv. no. DK 5

Acquired in 1954

Luděk Marold was considered one of the most brilliant drawers in Paris at the time and his illustrations, highly appreciated by contemporary critics, were of interest to the editors of *Le Monde illustré, La Revue illustrée, L'illustration, Figaro illustré* and other magazines. His drawing style quickly matured after his arrival in Paris and soon took on its unique, unmistakable form; with a great spirited style, the artist recorded the basic layout of the work in pencil, pen or directly with a brush, which he then washed with watercolour, accentuating details with white and often using the colour tone of the paper. He was able to overcome the difficulties of the watercolour technique with ease and skill and, with refinement and a sense for the beauty and fragile grace of the women he depicted, he presented scenes from the life of a fashionable society. Precise gestures, movements and a huge range of expressions in the individualised faces told stories, interpreted conversations or showed the various life situations of the inhabitants of the French metropolis. The art historian and critic Karel B. Mádl described Marold's diverse roster of protagonists in 1899 in *Volné směry (Free Trends)* magazine as follows: 'His people live, rest, rejoice, love and sigh [...] Carriages clatter on the pavement, fountains splash, [...] children play, conversations intertwine, glances meet.' A major theme for Marold was the dialogue between man and woman, representing moments sometimes of emotional tension or excitement, sometimes of harmony and relaxation. Among the most impressive works depicting scenes from the upper social classes is the watercolour *In the Boudoir*. Set in a lavishly furnished boudoir, the scene is a dialogue between an elegantly dressed gentleman and a beautiful young lady who listens to him while relaxedly posing with a somewhat bored expression. The drawing was the subject of an illustration printed in 1896 in the *Munich Fliegende Blätter* weekly and, as Caroline Sternberg recently pointed out in the publication *Epocha salonů (The Era of Salons)*, it was accompanied by the text: 'Emmy, have you noticed today [...] that the swallows are already heading south?' 'Surely, dear Paul, [...] are we going to Nizza this winter, too?' The absence of any serious or witty conversation was replaced this time by Marold's masterly drawing. ŠL

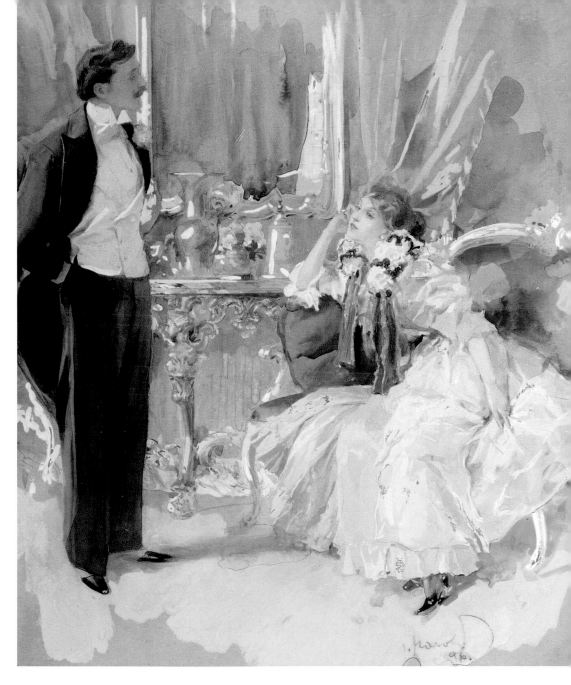

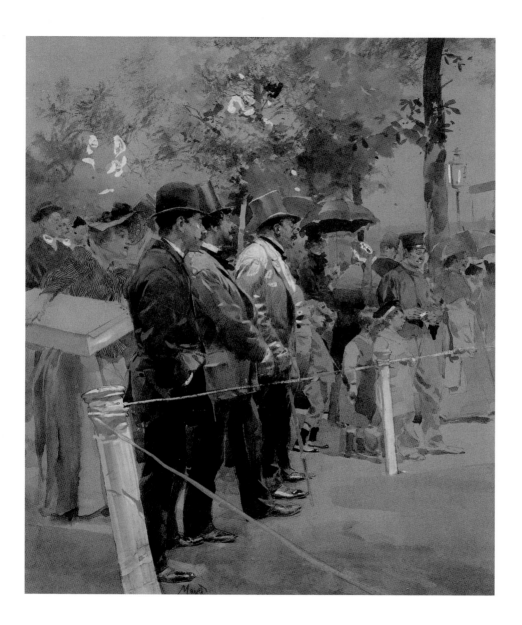

LUDĚK MAROLD
(Prague 1865–1898 Prague)

The Curious Folks of Paris (in Front of a Puppet Theatre), 1891

Watercolour, gouache and India ink on paper, 42.5 × 36 cm

Inv. no. K 100

Acquired in 1954

Luděk Marold was one of the greatest talents of the artistic generation of
the 1890s, and his work has always attracted the interest of collectors and
art lovers alike with its extraordinary drawing quality. Despite his untimely
death (he died when he was only thirty-three years old), Marold produced
a body of work comprising hundreds of drawings in which he was able to
render a true picture of the life of Parisian society in the last decade of the
nineteenth century. After studying at the academies in Prague and Munich,
Marold won a one-year scholarship with Pierre-Victor Galland's École des
beaux-arts in Paris in 1889. However, after only a few months, dissatisfied with
the professor's overly mechanical and cumbersome method, he left the school.
He was helped by Vojtěch Hynais, who lent him his studio in Montmartre,
but also gave him a commission for the Calman Lévy publishing house. Its
brilliant execution earned Marold further commissions, and his illustrations
were soon sought after by leading publishers of illustrated dailies and maga-
zines. Realistically conceived scenes, striving to achieve maximum illusion,
mastery of the painterly perspective and effective shading of the essentially
monochrome painting with accents of white, demonstrated the artist's drawing
mastery. Belonging to the category of realistic (or naturalistic) illustration,
Marold's works depicted the life of Parisian streets, parks, gardens, theatres,
exhibitions, restaurants and cafés, as well as artists' studios, boudoirs or salons.
Many of them were based on photographs taken as fleeting moments of real
life, and the trend of contemporary sentimentalism that played a significant
role in late nineteenth-century art cannot be ignored. *The Curious Folks of
Paris* belongs to these works, too; it was reproduced in the Prague maga-
zine *Světozor (World Review)* in 1891 in the series *Z pařížského života (From
Parisian Life)*, under the title *Obecenstvo kašpárkovo (Kasperle's Audience)*. In
a lively scene, Marold presented a diverse audience of street puppet theatre
performance, suspended in the middle of their bustling daily routine, watching
the performance with fascination and full of emotions. ŠL

HUGO BOETTINGER

(Pilsen 1880–1934 Prague)

Beach in Ostend II, 1906

Pencil and watercolour on paper, 12 × 16.5 cm

Inv. no. K 62/2

Acquired in 1954

In the work of Hugo Boettinger, two positions intertwine which are related to the tumultuous period at the turn of the twentieth century. The first one is classified as official academic painting, represented in Boettinger's work mainly by erotic compositions of young women nudes, which catered to the bourgeois taste of the time. The second, more familiar part of the painter's œuvre concentrates on a more vivid depiction of contemporary life, especially in drawings and caricatures. Boettinger's drawing work is abundant and characterised by a brisk sketchy stroke that was already more in keeping with the accelerated pace of modern times. It was also influenced by the painter's travels abroad, during which he had become acquainted with foreign art. As a sworn opponent of the new modern tendencies, which he satirised in his drawings, he focused more on more traditional painting (following, for example, the model of James Whistler). Boettinger's scenes from beaches, which he painted and drew on a joint trip with the painter and graphic artist Tavík František Šimon, may refer to Manet's well-known works from the late 1860s and early 1870s. Boettinger's scene from the beach in Ostend is a multi-figure seascape, very lightly sketched, yet well thought out in composition and colour. It divides horizontally into a sandy beach with figures, above which the sea surface and bright sky open. The blue is repeated in the foreground, where the sky and seated figures are reflected in a large puddle; the sea and the reflection of the sky thus frame the whole scene above and below. The colour palette is soft, focusing on ochre, blue and grey tones; among these, the strong red accent of the girl's clothing on the right dominates and is complemented by several splashes of colour on the figures in the background. The whole scene feels authentic and vivid thanks to the quick, sketch-like drawing. There are other compositions by Boettinger from Ostend, as well as oil paintings, but they do not compare with the liveliness of the drawing from the Gallery of West Bohemia in Pilsen. AP

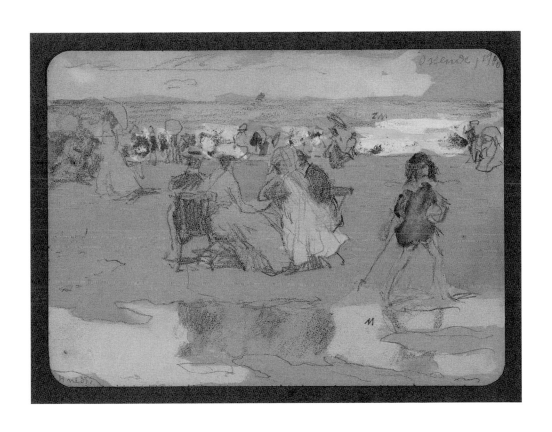

Max Švabinský
(Kroměříž 1873–1962 Prague)

Portrait of a Woman Reading, c. 1893

Charcoal and white chalk on brownish paper, 73 × 58 cm
Inv. no. K 945
Purchased in 1973

This portrait was drawn by the twenty-year-old artist about halfway through his studies at the Academy of Fine Arts in Prague in 1891–96 under the guidance of Maxmilián Pirner. The work was created in the school studio, as the Academy was then located in the building of the School of Arts, Architecture and Design at the former roadstead on the Moldau embankment. The opposite building is the Rudolfinum, the Neo-Renaissance House of Artists, opened in 1885; it was in its halls that Švabinský celebrated his first artistic achievements at the annual exhibitions of the Krasoumná jednota (Fine Arts Association) a few years after this drawing had been made. However, Professor Pirner was able to appreciate Švabinský's extraordinary artistic talent early on during his studies and encouraged him to specialise in freehand drawing which, after 1900, would culminate in large-scale ink drawings combined with watercolour and tempera. Considering its technique (charcoal and chalk), this drawing is quite large, which enabled the young artist to put a distinct line separating the intimacy of the interior with the sitting woman from the outside world behind the window. The woman's three-quarter figure, shown in profile, is brought closer to the viewer by a quasi-photographic style of cropping. The drawing is sometimes presented under a more concise title *Reader*, and the elderly woman depicted in a white cap is reminiscent in form of the artist's favourite model of the 1890s, 'Aunt Máry', his grandfather's sister from Kroměříž. Dozens of student drawings or paintings have survived from the time the artist spent at the Academy; however, the *Portrait of a Woman Reading* has a different meaning. Already with this early work, which belongs among the first entries in his life œuvre, Švabinský demonstrated his mastery as a drawer and in the same decade established himself as the official portraitist of the national elite. In this capacity he worked during the last years of the Austro-Hungarian Empire, the First Czechoslovak Republic (1918–38) and even in the post-war era, most often using either pen, charcoal or one of the printing techniques to create his works. AF

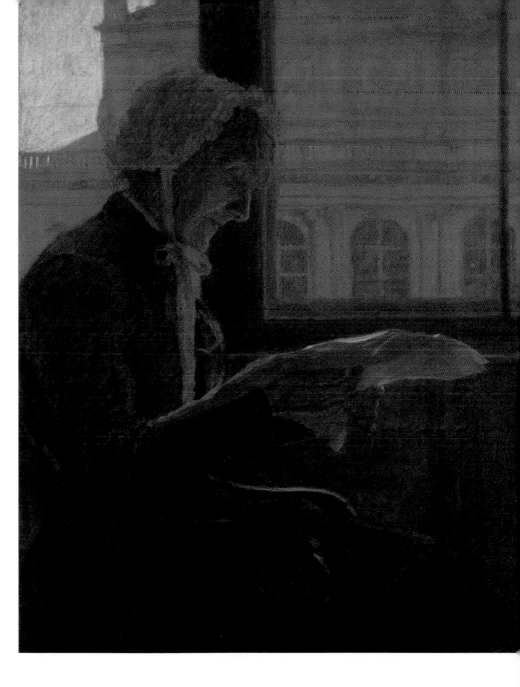

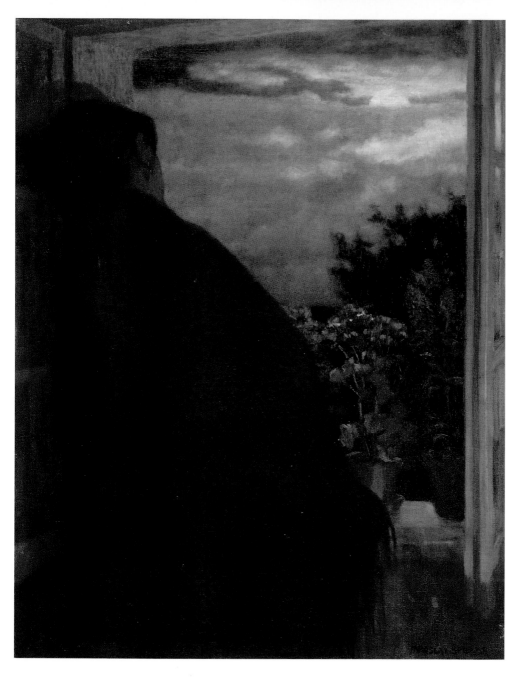

Jaroslav Špillar
(Pilsen 1869–1917 Dobřany)

By the Moonlight, 1898

Oil on canvas, 64 × 48 cm
Inv. no. O 297
Purchased in 1960

At the beginning of 1899, Jaroslav Špillar held his first solo exhibition in Prague's Salon Topič, where he presented eighty-six works representing his œuvre to date. At that time, Špillar was appreciated by art critics primarily as a painter of the Chod people, thanks to his numerous ethnographically oriented genre paintings of the history and current times of this West Bohemian ethnic group and its region. In addition, however, he attracted attention with several of his genre works of civilian life. Prominent among these was the painting *By the Moonlight*, which Špillar painted in 1898, certainly in preparation for his forthcoming retrospective exhibition, where he intended to display it. It depicts his wife Anna in a room in their house in Postřekov near Domažlice, looking through an open window into the night landscape. The woman has a distinctive red shawl draped over her shoulders, which takes up almost half of the picture's surface; by using this monochrome element, the artist shifts the formal appearance of the painting almost to the position of a poster work. In order to give it a special melancholic and intimate atmosphere, Špillar used the principle of the so-called *Rückenfigur*, i.e. the depiction of a figure from behind. The protagonist's face is not visible, and the viewer watches the action unfolding in front of her through her figure. The principle of *Rückenfigur* was introduced by the nineteenth-century painter Caspar David Friedrich, an important exponent of German Romanticism, who portrayed his wife Caroline in this way several times, for example in his famous work *Frau am Fenster* (1822). This principle was often utilised by the influential representative of Danish symbolism Vilhelm Hammershøi and his Czech follower Jakub Schikaneder; however, unlike these authors, Špillar did not work with the rule of juxtaposition in his work. He confronted two worlds, the existential one, represented by the female heroine in the confined space, and the one outside the window, often interpreted as a symbol of freedom and the infinite universe. Špillar painted his wife about a year after their wedding and the expression of romantic longing seems to be outweighed by the attributes of a happy family background, such as the warm colour tones of part of the room or the window with the potted geraniums. RM

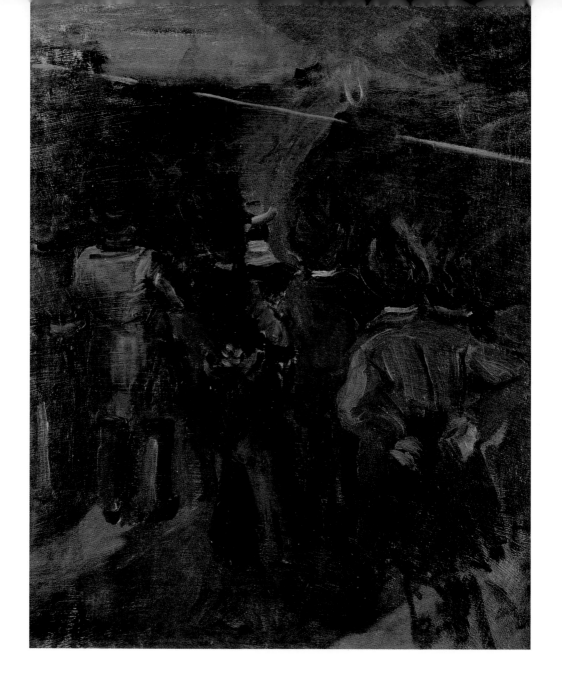

Miloš Jiránek
(Lužec nad Vltavou 1875–1911 Prague)

Football Fans (study), 1901

Oil on cardboard, 57 × 46 cm
Inv. no. O 727
Purchased in 1967

Football was a great passion of the painter Miloš Jiránek. The popularity of
this sport in Bohemia soared rapidly from the 1890s. Football was played by
representatives of different social classes; it was truly a democratic pastime.
It entered the work of many artists as one of the distinctive attributes of life
in modern urban society; for Jiránek, however, it was something even more
important. He revisited this subject frequently, and devoted himself to it in
his personal life as an avid fan and player. Together with his brother Ladislav,
Jiránek was a supporter of SK Slavia Prague football team. From 1899, he was
a member of the 'Chess Football Club' and actively participated in matches.
During 1901 and 1902, Jiránek painted six paintings on football-related topics.
In this painting from the Gallery of West Bohemia in Pilsen, he did not focus
directly on the game – the audience was what interested him there. He depicted
the standing spectators in a quickly painted oil sketch in a contrasting palette of
sharp and soft tones. He applied thick paint to cardboard with vigorous brush-
strokes. Owing to this, the scene of the match itself at the top of the composition
is blurred, yet it is where the eyes of the audience, with their backs turned to
the viewer, are fixed. The sketch thus differs from Jiránek's other paintings
on football themes, in which the painter focuses on the action on the pitch,
framed by the surrounding urban ambience. According to the art historian
Jiří Kotalík, this group of Jiránek's paintings culminated in a large canvas, the
trace of which was lost somewhere in a private collection in Moravia; on the
other hand, another historian, Tomáš Winter, expresses doubt whether Jiránek
ever painted a large painting with a football theme. From 1901 onwards, he
worked on another motif from the sporting environment, which he eventually
depicted in the monumental painting *Showers in the Prague Sokol* (1901–03).
Jiří Padrta saw in Jiránek's sport-themed paintings a developmental shift in
artistic expression, abandoning historical allegory and moving towards the
pathos of modern man's everyday life. MR

JAN PREISLER
(Popovice, near Beroun 1872–1918 Prague)

Football, 1906

Oil on canvas, 32 × 46 cm
Inv. no. O 186
Purchased in 1957

Since the end of the nineteenth century, football has been one of the most
popular sports in the Czech lands. The cradle of its modern form is often
seen in England, from where it was imported to our country. Together
with some other sports disciplines, it soon became not only a symbol of
the new era and modern way of life, but also entertainment for the masses,
attracting thousands of supporters – including Jan Preisler, a die-hard
fan of the Czech football club SK Slavia, whose team was one of the most
successful in Europe at the beginning of the twentieth century. When
a new and the first fully grassed pitch in the Czech lands was built for
this sports club on Prague's Letná fields in 1901, Preisler reportedly did
not hesitate to change his residential address and move to an apartment
house adjacent to the pitch so that he could occasionally watch football
matches from the window of his room. According to the testimony of the
painter Otakar Nejedlý, Preisler was a very passionate football fan who
would get emotional during the matches and comment on them equally
emotionally. Preisler's passionate attitude towards the game was reflected
in his painting *Football*, which he painted probably in 1906, when Slavia
played its first friendly match with the Hungarian Ferencvárosi Torna
Club. The green-and-white striped jerseys of the opponents, which were
characteristic of this team from Budapest, suggest this. The small-format
painting gives a very lively impression, reminiscent of a contemporary
photographic snapshot, and is painted in a rather hasty manner, i.e. with-
out any underpainting, with a very dry and quick brush, thus capturing
the dynamic atmosphere of the moment on the pitch. The theme from
a sports environment is quite unique in Preisler's work. It shows, among
other things, that the author of mostly large symbolic and allegorical
themes was not as detached from everyday life as his previous work might
suggest. With this painting, he thus placed himself among some of his
contemporaries, such as Miloš Jiránek, František Xaver Naske and Josef
Koudelka, who paid attention to football in their works of the time. RM

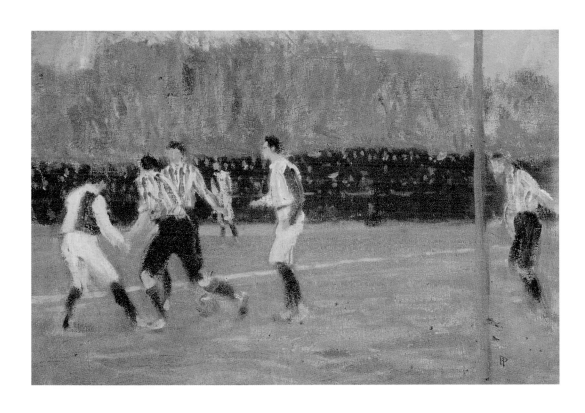

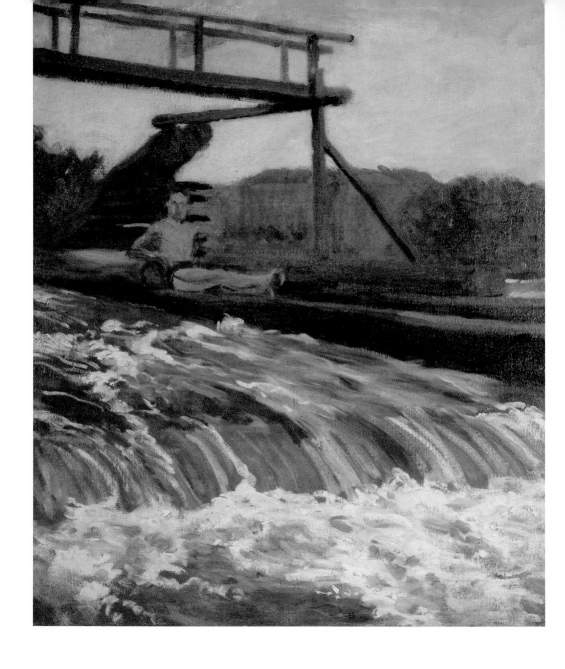

Miloš Jiránek
(Lužec nad Vltavou 1875–1911 Prague)

Weir (study for Weir at Palacký Bridge), 1905

Oil on canvas, 69 × 56 cm

Inv. no. O 716

Purchased in 1967

Miloš Jiránek was an important representative of the generation of Czech art-
ists associated with the 'heroic period' of the Mánes Visual Artists Union. As an
educated, francophone intellectual, he participated in the union's activities,
including working for many years as an editor of *Volné směry (Free Trends)*
magazine. Jiránek's contemporaries and later interpreters of his work failed
to appreciate his paintings, however, which have an unfinished character,
due to the artist's untimely death. Jiránek studied at the Prague Academy of
Fine Arts under Vojtěch Hynais. The lessons of Hynais's luministic *plein air*
verism (a trend emphasising the realistic approach to pictorial representation,
characterised by a free style of combining bright colour spots expressing
luminous quality of outdoor scenes) prepared him to accept certain impulses
of impressionism; however, in his approach to the nude – especially the male
nude – Jiránek was able to free himself from the academic allegory that was
still seen in Hynais's work. Jiránek's 1905 painting *Weir* is a study for the final
version of the subject entitled *At the Weir* (1905–06) from the Gallery of Fine
Arts in Cheb, another study for which is in the National Gallery in Prague.
In these works, Jiránek took up the thread, among other things, of the paintings
he made in Obříství in 1898, in which he had already developed a sensualist
approach to the treatment of the naked male body in the open air. In 1900,
Jiránek terminated his studies at the Prague Academy of Fine Arts and travelled
to Vienna, Venice, Trieste and Paris. After his return, he painted intensively
beside the weir at Palacký Bridge and in Prague's borough of Troja. In his now
lost painting *Twilight* from 1901, in which he painted his brother Ladislav
sitting at the weir near Palacký Bridge, he switched from veristic luminism
to expressively accented, thick-paint brushstrokes. From *Twilight*, a straight
path leads to the painting *At the Weir* and the study *Weir*. In his paintings,
Jiránek confronted the water element with a semi-nude male. The figure sits
calmly above the raging torrent of rushing water, and it is this contrast that
brings an interesting tension to the painting. MR

Bohumil Kubišta
(Vlčkovice 1884–1918 Prague)

Promenade in Riegerovy Gardens, 1908

Oil on canvas, 126.5 × 163.5 cm
Inv. no. O 380
Purchased in 1961

Bohumil Kubišta entered the art scene at the beginning of the twentieth century. He was a member of the Osma (Eight) group (1907–08), associated with expressionism in the Czech milieu; however, he never joined the activities of the cubist Group of Visual Artists (1911–14), although he introduced the work of Pablo Picasso upon his return from Paris. Members of Kubišta's generation were characterised by their desire to break free from provincialism; they therefore studied at foreign academies (Bohumil Kubišta in Florence in 1906–07). For the same reason, they travelled abroad and visited museums, where they were interested in the works of both old and modern masters. In Prague, they rejected the previous art nouveau generation and unjustifiably overlooked the merits of the Mánes Union of Visual Artists in modernising the local art scene. In doing so, the exhibition of Edvard Munch, organised by the Union in 1905, provided a valuable lesson to the members of the Osma. The strong influence of Munch is also seen in the *Promenade in Riegerovy Gardens* (1908), which is on the reverse of the painting *The Resurrection of Lazarus* (1911–12). Throughout his career, Kubišta wrestled with a lack of resources which, among other things, forced him to reuse his canvases. The not very recognisable motif of the promenade can be found on the reverse of *The Way of the Cross* (1910) from the Gallery of West Bohemia in Pilsen, while the most sophisticated and dynamic presentation of the theme can be found on the reverse of the painting *In Our Yard* (1907) from the National Gallery in Prague. Munch's lesson in these paintings of promenades resonates in the choice of subject matter: in fact, Munch's *Evening on Karl Johan Street* (1892) with a crowd looking at the viewer was exhibited in 1905 at his exhibition in Prague. But it also manifests itself in the deformation of the figures and the landscape. All Kubišta's 'promenade' paintings are characterised by a strong colour palette. Here, the painter used the luminosity of contrasting colours to create the impression of flattening or, on the contrary, mass plasticity. Kubišta chose the colours of the individual figures to differentiate the respective types of the actors in the scene. MR

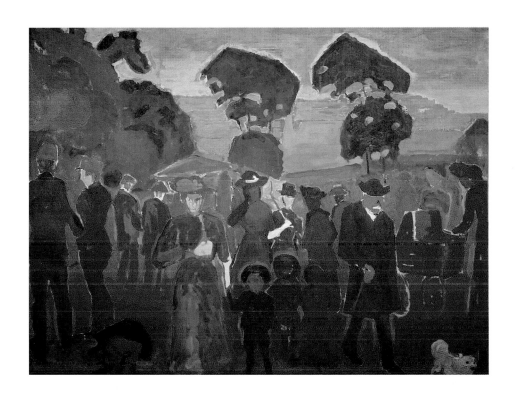

EMIL HOLÁREK
(Louny 1867–1919 Prague)

Evening, 1890–1895
India ink on paper, 36.5 × 24 cm
Inv. no. K 1135
Purchased in 1990

The evening return of the herd in the rays of the setting sun became the subject of paintings and drawings by the Swiss symbolist Giovanni Segantini in the 1880s; one of them is in the collection of the National Gallery in Prague. The motif of returning peasants from the fields can also be found in Václav Brožík's genre paintings from Brittany. Following these and other artists of his time, Emil Holárek potentially wanted to evoke an evening moment of peace and harmony with the universe and divine order, to which the depiction of a wayside shrine would refer. However, one detail is important for the correct 'reading' of the drawing: the shepherd does not raise his hat to the wayside shrine, as one might expect, but to greet the person near it. However, this would remain a secret even to an attentive observer were it not for the handwritten inscription on the back of the drawing. When it was acquired for a public collection, the accompanying information was written on the reverse and, in the absence of the artist's signature, the authorship was confirmed. We thus learn that this is one of Holárek's earliest works – a pen drawing that was the first study for the fourth painting in his *Reflections from the Catechism* series (1901), entitled *Pride* (from the opening series of the cycle, entitled *The Seven Deadly Sins*), and the first preparatory drawing for the entire series. The artist had rethought the subject twice more before arriving at the final version for the cycle completed in 1895. In the final version, the shepherd is replaced by a reaper, whose greeting is condescendingly unanswered – and the sin thus personified – by a well-to-do butler sitting on a bench in front of a castle. From the beginning of his independent work in around 1890, Emil Holárek concentrated both on historical paintings and on spiritual drawings with an appealing and persuasive message, which eventually – in the form of annotated series published in print – brought him much fame. A moralist and ironist, Holárek criticised socially conditioned hypocrisy incompatible with authentic Christian belief. He was influenced artistically by the German representative of pre-symbolist spiritual painting and author of popular graphic cycles, Max Klinger. AF

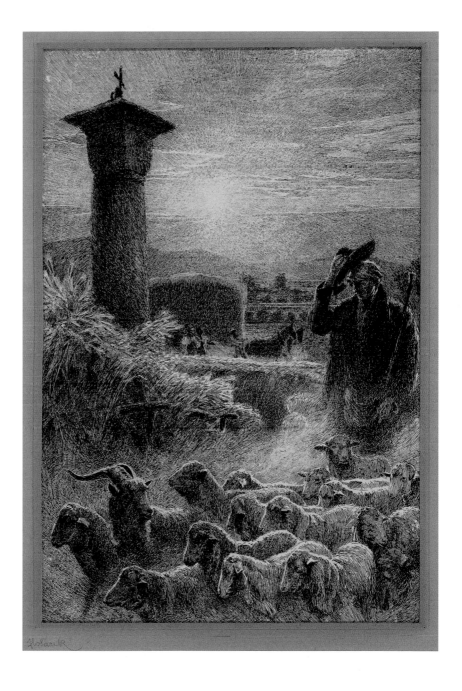

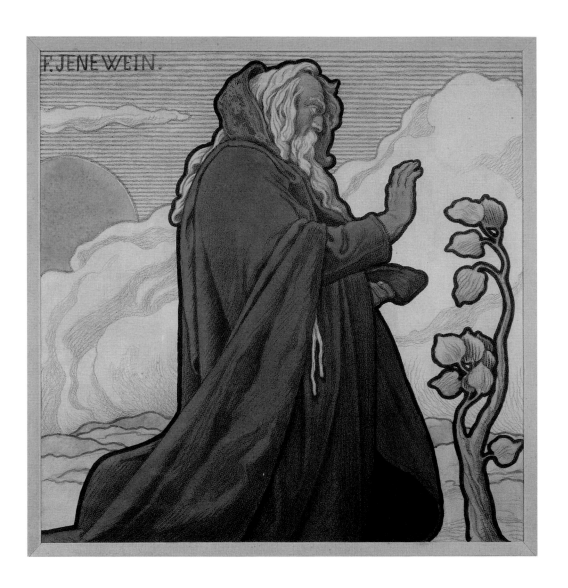

FELIX JENEWEIN
(Kutná Hora 1857–1905 Brno)

Abraham, 1901

Gouache on paper, 32.5 × 32.5 cm

Inv. no. K 22

Acquired in 1954

Around 1900, Felix Jenewein was commissioned by the Austrian Ministry of Culture and Education to decorate Vienna's Holy Family Church, built in the 1890s to a design by architects Alexander Wielemans and Theodor Reuter in the Neu-Ottakring. The Czech artist was originally commissioned to design twenty panels for the nave of the church with figures from the genealogy of Jesus Christ and the apostles, developing the iconography of the church consecration. Jenewein's initial idea was that the figures of the saints would be upright and in rectangular fields. However, the ministry eventually decided that the format of the fields would be square, and that the Old Testament figures would be depicted kneeling and in profile. From 1901 onwards, Jenewein had to submit three of his designs to the Ministry for approval each year. One of the first gouache drawings he produced was that of Abraham. The majestic, priestly figure of the patriarch blesses the growing tree with giant leaves as a symbol of the young and expand- ing nation chosen by God. In this perfect drawing, which does not lack a sense of monumentality, the influences of late Nazarene style collide with the manifesta- tions of high art nouveau. Jenewein began working on studies for the Viennese church immediately after he completed his key work in 1900 – a series of six gouache drawings of *The Plague* – and the decoration of the Viennese church became another crucial work for the Czech artist. It was the largest commission he had ever received; however, it remained unfinished due to his untimely death in 1905. During his lifetime, the artist produced the following studies: *Isaac* and *Jacob* (in addition to *Abraham*) in 1901; *Judah, Boaz* and *David* in 1902; *Solomon, Hezekiah* and *Matthan* in 1903; and finally *St. Joseph, Apostle Andrew* and *Apostle James the Greater* in 1904. Three designs, *Apostle Bartholomew, Apostle Philip* and *John the Evangelist* remained unrealised. Jenewein's twelve designs of biblical figures were finally transformed into large-scale murals on the opposite walls of the nave by Czech artists Karel Rašek and Vilém Trsek. The remaining eight designs were commissioned to be completed by the Tyrolean artist Ferdinand Andri, who belonged to the religiously oriented wing of the Vienna Secession. RM

František Bílek
(Chýnov 1872–1941 Chýnov)

The Good Shepherd, 1900–1901 (original sculpture),
1910s–1920s (sculpture depicted)
Lime wood, H. 36 cm
Inv. no. P 82
Purchased in 1960

František Bílek, a Czech sculptor and versatile artist of art nouveau symbolism, was initially misunderstood and faced rejection. His early works from the 1890s, which combined elements of art nouveau and naturalism, even irritated the public with their incomprehensible content and unconventional form. The headline of the very first article about Bílek read 'Sochař mystik' ('The Mystic Sculptor', 1896), as the artist sought a distinctive interpretation of the Gospel based on a subjective interpretation of biblical texts, initiated and fostered in him by several visions of Jesus Christ. This trend culminated in a series that was the artistic antithesis of Alfons Mucha's *Our Father* (1899). Bílek's *Our Father!*, published in 1901, contains eighteen lithographs and reproductions of drawings with his own text in hand-written calligraphic script, and photographs of three of his sculptures. *The Good Shepherd* is reproduced on the thirteenth sheet of the fifth prayer from the album *Our Father!* with the text: 'How sweet it must be: a lost sheep, found by the Good Shepherd, sheltered in His dearest, eternal embrace!' The sculptor is referring to Christ's parable of the lost sheep and the joy of finding it in the Gospel according to Matthew (18:12–13); according to his interpretation, it is the human soul that 'is like a sheep: silent, not complaining, devoted', submitting to God. The fifth petition of the Our Father is: 'And forgive us our trespasses, as we forgive those who trespass against us.' In the spirit of the Christian doctrine, the connection of the parable to this petition is evident. *The Good Shepherd* is one of František Bílek's most comprehensible works, popular with the public. In contrast to the traditional iconography of the Good Shepherd carrying the once lost and now found sheep on his shoulders, Bílek's figure is squatting, which has many analogies in his sculptural work, e.g. in the *Parable of Our Time* (1897) or the *Ploughing with the Cross* (part of the *Our Father!* series), while at the same time accentuating the gesture of fervent emotion, mercy and protection. The priest and writer Jakub Deml noticed that the outline of the statue resembles a heart resting on its side. AF

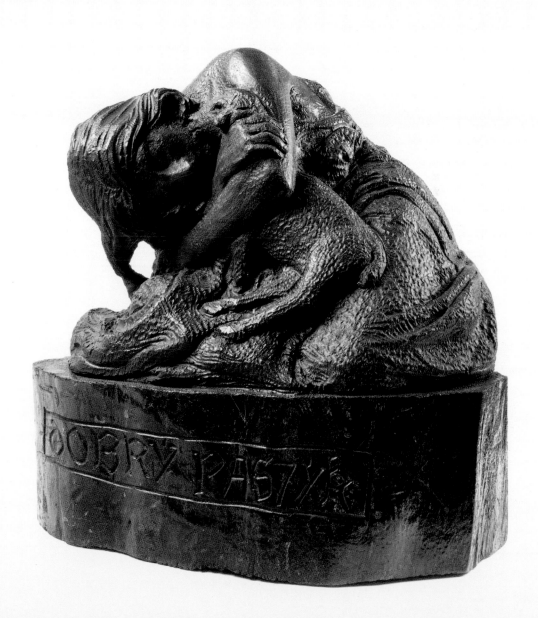

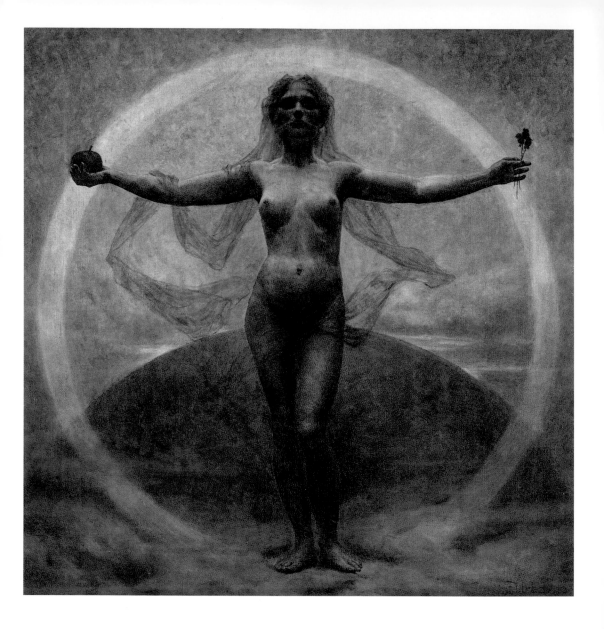

František Urban
(Prague 1868–1919 Prague)

Woman's Fate, 1895–1900

Oil on canvas, 55 × 55 cm
Inv. no. O 90
Acquired in 1953

This symbolist painting by the Prague painter František Urban somewhat deviates from the main direction of his work. After 1900, the artist focused on the decoration of church interiors (murals, stained glass, altarpieces), in which the artist's wife, Marie Urbanová-Zahradnická, his classmate from the School of Applied Arts in Prague, repeatedly participated. Great attention was drawn to his triptych *Gold* (pre-1900), exhibited at the Künstlerhaus in Vienna, the central part of which was reproduced in the Berlin magazine *Moderne Kunst* in 1900. This now lost work, with its theme of the struggle for property, also had an allegorical-symbolist character. However, unlike *Woman's Fate*, or the painter's later, now popular painting *Angel* with the figure of God's messenger in a field of grain, *Gold* carried a straightforward message, pointing out the contradiction between Christianity and social Darwinism. The small square canvas *Woman's Fate* is conceived as a nocturne in a reduced colour palette with an emphasis on the contrasting light, thus resembling a charcoal drawing. A female nude with outstretched arms is painted inside a circle as an allusion to a rainbow or a halo. The naturalistically painted figure in counterpoise, whose belly may suggest impending pregnancy, contrasts with the uncertain environment – perhaps the Earth emerging from the waters after the Creation. To soften this contrast, the painter has covered the woman's face and lap with billowing stripes of a black veil. The woman holds three poppies in her left hand and an apple in her right, referring to the biblical Eve and Original Sin; her lap occupies the centre of the composition. The poppies symbolise death, eternal sleep, and together with the black veil may suggest the fate of the widow. The water surface in the background refers to the feminine element, while the self-confident posture of the figure in this otherwise melancholic work refers to the motif of the female ruler and the issue of the struggle of the sexes. One could go on searching for meaning – the multi-layered, symbolist character leaves room for mystery. AF

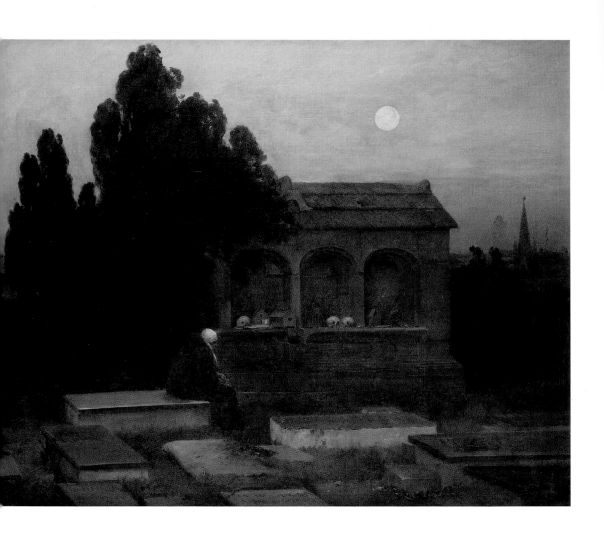

VÁCLAV BROŽÍK
(Třemošná, near Pilsen 1851–1901 Paris)

At the Graveyard, c. 1890–1895

Oil on canvas, 105 × 130 cm
Inv. no. O 835
Purchased in 1971

Václav Brožík was born in a trip-hammer workshop in Třemošná near Pilsen, which has always claimed him as a famous native son. The work of this painter, whose dazzling Parisian career was something exceptional in Bohemia, was in great demand among collectors and it is no wonder that Brožík's collection in the Gallery of West Bohemian is very large (it contains around thirty paintings). From the late 1880s onwards, in addition to the spectacular canvases on historical themes for which he became particularly famous, he also devoted himself to landscape and rural genre painting. Brožík's landscapes are modern *plein air* records and do not deny the influence of French landscape-painting school, especially the works of Jules Breton. Brožík painted rural people at work and rest, and at different times of the day. When in France, he spent the summer months at his father-in-law's chateau in Ambleville on the border of Île-de-France and Normandy. He also visited Brittany, where he stayed with friends at the Château de Monthorin in Louvigné-du-Désert. Brittany, with its rugged nature and peculiar local customs, had attracted painters since the Romanticism era. It was very popular in the last decades of the nineteenth century, and some towns had the character of painters' colonies. Of the Czech painters attracted to Brittany, Jaroslav Čermák settled in the port of Roscoff as early as 1869. Brožík's painting *At the Graveyard* was purchased under the mistaken title *The Père-Lachaise Cemetery in Paris with the Tomb of James Rothschild*. Only recently has it been clarified that it is a Breton motif and depicts the ossuary at Saint-Pol-de-Léon near Roscoff. It is an almost symbolist-decadent cemetery scene: an old woman sits at dusk on a grave in front of the ossuary; the tower of the local cathedral looms in the background, the dark trees surrounding the ossuary, together with the pale moon above, underline the melancholic atmosphere of the scene. In the niches of the ossuary, human skulls flash white next to strange little chapel-shaped boxes with crosses on top. According to a local custom that survived into the nineteenth century, it was common for bones to be transferred to the ossuary five years after the burial to free up space for more burials. The skulls used to be displayed separately in these wooden painted boxes, bearing the names and details of the deceased. IS

VÁCLAV BROŽÍK

(Třemošná, near Pilsen 1851–1901 Paris)

Nocturne (unfinished), before 1901

Oil and charcoal on canvas, 99 × 104 cm

Inv. no. O 398

Acquired in 1962

The final stage of Václav Brožík's painting career was marked by serious illness; the painter had suffered from Ménière's disease for a long time, which he had hoped to overcome by stays in the French countryside. He liked to go to Normandy and Brittany for the summer season, resting amidst the countryside, but also working. In the last years of his life, he often painted the surrounding fields, villages and seashore on small wooden plates; in his studio, he then worked on various genre scenes from the countryside. One of the last paintings to remain in progress was *Nocturne,* sometimes referred to in earlier literature as the *Late Return from Normandy.* The scene shows an old man with a cane, dressed in a long coat, leading a little girl by the hand. They walk through the evening landscape past a field of upright sheaves, the moon appearing in the sky between the clouds. The work is already clearly laid out (there are two drawing studies for the work, housed in the collections of the National Gallery in Prague) and the landscape and the figure of the old man are prepared with underpainting; only the figure of the little girl carrying a small bundle or basket in her hand is sketched in charcoal. Even though the work remains unfinished, it impresses us with its expressive power, its social theme, and above all its artistic concept, in which the strange combination of yellow, green, grey-blue and black tones evokes a magical evening atmosphere. Tomáš Vlček, who singled out the canvas in his 1982 catalogue *Světlo v českém malířství (Light in Czech Painting),* wrote: 'Brožík was not a pure landscape painter and the landscape was for him a means of psychological shading of the figure. [...] Following Millet's landscape figure motifs, Brožík sought a new, more subtly psychologically shaded expression, which was already inspired by the decadent moods of the time. Only the power of inner vision could lift him above them.'

The painter died in Paris on 15 April 1901 of heart failure and was buried in Montmartre cemetery. His Czech estate, which was in the painter's studio in Revoluční Street in Prague, was purchased by the Imperial Counsel Václav Knight Špaček, the owner of Kokořín Castle, who bequeathed a large part of it to the city of Prague in 1914. ŠL

JAN FRANTIŠEK GRETSCH
(Prague 1866–1894 Prague)

The Salvatorian Legend, 1893

Oil on canvas, 166 × 280 cm
Inv. no. O 413
Acquired in 1962

The Prague painter Jan František Gretsch died of pulmonary tuberculosis at the age of twenty-eight. From 1891, when he finished his studies at the Academy of Fine Arts in Prague under Maxmilián Pirner, he had only three years of independent work ahead of him. In the penultimate year of his life, he exhibited a large-scale painting, *The Salvatorian Legend*, at the fifty-fourth annual exhibition of the Fine Arts Association in the Rudolfinum, the plot of which he explained in the exhibition catalogue. It refers to the execution performed on 21 June 1621 in Old Town Square in Prague of twenty-seven Czech nobles and burghers who rebelled against the Habsburg monarchy and were defeated in the Battle of White Mountain (1620). According to legend, on the anniversary of the day of their execution, the souls of twelve of them, who are buried in the Protestant Church of St Salvator, return to their bodies at midnight and pray for their Church.

'Christ, in a blaze of light, administers the Holy Communion *sub utraque species* to them, whereupon they march in mournful procession to the square. If they see the hour hands of the Old Town clock move, they return to their tombs in satisfaction. But if they see the clock standing still, they bow their heads and pray for better times to come for their country, and then return to their hidden tombs.' Since the painting shows figures only arriving at the clock tower, it is not yet clear which of the two alternatives they will encounter; the raven in the foreground, though, does not bode well. Gretsch gave his painting the character of a dream-like nocturne with Christ in a white robe and the figures of the nobles coming from the great beyond. This concept stands out especially when compared with the painter Karel Šimůnek's descriptive rendering of the same subject. Gretsch's neo-romantic painting is half bathed in white light, while the background is plunged into darkness. The construction of the space is based on parallel and crossed diagonal lines with a link to the light. The critics of the time spared no praise: for example, Karel Matěj Čapek saw this piece as 'the best of all the works by young talents exhibited this year', attracting attention 'by its power and enthusiastically conceived plot'. AF

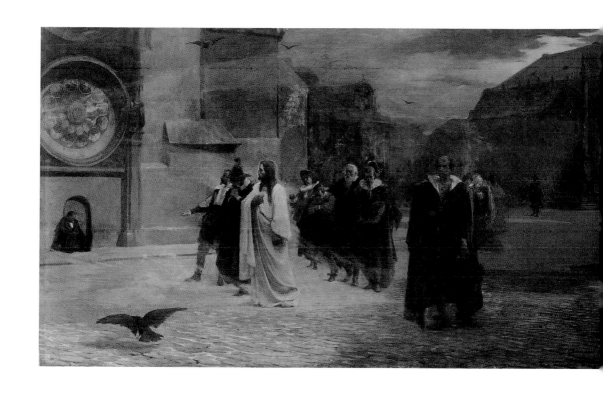

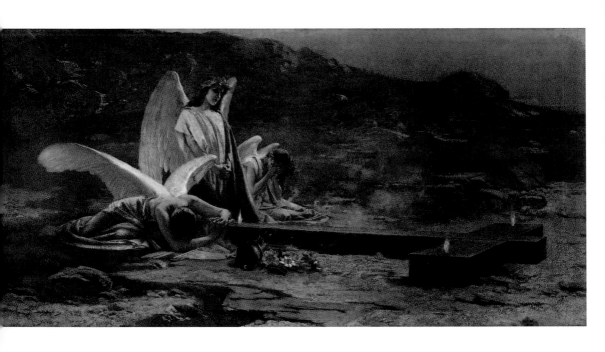

Emanuel Krescenc Liška
(Mikulovice 1852–1903 Prague)

The Dawn after Good Friday, 1903

Oil on canvas, 167 × 336 cm
Inv. no. O 1618
Purchased in 2022

Emanuel Krescenc Liška was a member of the 'National Theatre Generation';
he took part in decorating the theatre at the turn of the 1880s. He was also one of
the most prominent protagonists of Czech art of the fin de siècle and his work
was strongly influenced by historicism, neo-romanticism and symbolism. Part
of his work was inspired by biblical motifs from the life of Jesus Christ, which
he treated in an unconventional way in the spirit of Christian symbolism with
a great emphasis on the psychological state of the figures depicted. Of these
works, the most important is the painting *Christ on the Mount of Olives* from
1886, which was created during Liška's stay in Rome in 1885–87. One of the
last pieces on which Liška worked up until his untimely and sudden death
in early 1903 was a painting of extraordinary proportions and monumental
appearance, *The Dawn after Good Friday*. Liška chose an unusual subject
for it: in a rocky landscape, a cross lies without the body of Christ. Symbolic
flames of faith burn on its arms, heralding Christ's resurrection; at the foot of
the cross, three angels are mourning and praying. The artist used a brilliant,
smooth valeur painting (painting technique using various shades of the same
colour, aiming at realistic expression of volumes and depth of pictorial space),
which he combined with a rough texture on the surface to depict the rocky
setting of Calvary hill. Here, too, Liška lived up to his reputation as an excep-
tional painter, able to capture in a unique way the atmosphere of the dawning
of a new day with the alpenglow in the sky. Two preparatory sketches for the
painting have survived, titled *The Dawn on Golgotha* and *The Morning after
Good Friday*. In Liška's obituary, written by the sculptor Josef Mauder, published
immediately after the artist's death in 1903, the work is first mentioned as *The
Night after Good Friday*. In view of the light arrangement of this magnificent
scene and the upright figure of the central, kneeling angel, whose focused and
calm expression suggests that after the uncertainty of the sleepless night comes
the hope of the subsequent resurrection of Christ, we are inclined to use the
later title, which better corresponds to the iconography of Liška's work. RM

JOSEF MANDL
(Pilsen 1874–1933 Prague)

Soul (The Dug-over Grave), 1899

Oil on canvas, 70 × 83 cm
Inv. no. DO 39
Acquired in 1954

The painter Josef Mandl, a graduate from the Academy of Fine Arts in Prague under Professor František Sequens (1836–1896) and Václav Brožík (both of whom, like him, came from the Pilsen region), was a contemporary of the main representatives of Czech symbolism – Jan Preisler, Max Švabinský, Antonín Hudeček and František Bílek. Unlike them, however, he became an almost forgotten artist for a long time, receiving attention only in the regional context of Pilsen. This did not change until the twenty-first century, when his work began to be discovered in the broader context of religious art, neo-romanticism, symbolism and decadence. However, his predominantly macabre themes and formal conception are more in line with Pre-Raphaelite salon painting than with art nouveau symbolism. Mandl unwittingly contributed to his long neglect by avoiding exhibitions except in the early phase of his work. In 1899, the Fine Arts Association held its sixtieth anniversary exhibition at the Rudolfinum, at which Mandl was represented by two paintings, *The Coming of Spring* (pre-1900) and *Soul*. The latter was offered for a relatively low price of 200 florins (corresponding to the reputation of a budding artist); however, it must have been considered a significant work because it was reproduced in the illustrated catalogue of the exhibition (only 48 of the 846 exhibits were depicted in it). This reproduction confirms that the painting now referred to as *The Dug-over Grave* was originally titled *Soul*. The scene, set against the cemetery wall at dusk or dawn, catches the eye by the contrast of two adjacent graves: one well-kept, with a burning lamp and a wreath around the arms of the cross, and the other derelict, with a leaning cross and a grave pit only partially covered by boards, on which the gravedigger has left his shovel. This is a grave that has been emptied for further use, and from it, a white-faced apparition of a female figure, representing the soul of the deceased, is now emerging. Cemetery romanticism remained popular in art throughout the nineteenth century, but Mandl dared to go further than others by painting the soul separated from the body after death. AF

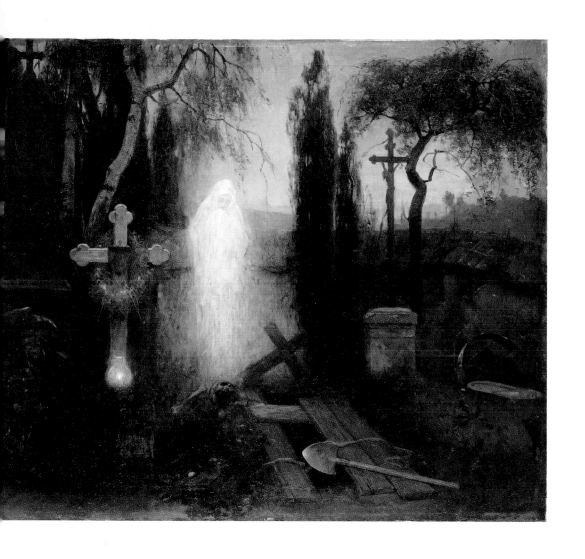

JOSEF MANDL

(Pilsen 1874–1933 Prague)

Female Saint, 1900

Oil on canvas, 75 × 115 cm

Inv. no. O 159

Acquired in 1955

In the year of its creation, the painting *Female Saint* was reproduced and commented on in the magazine *Zlatá Praha (Golden Prague)*. While the artist himself avoided any further historical identification of the depicted figure, the critics of *Zlatá Praha* – quite rightly – saw an early Christian martyr: 'She lies, young and dead, somewhere in the catacombs, laid upon a white sheet, the lily of innocence and the palms of martyrdom at her side. Light cuts through the dark dungeon and meets the phosphorescent halo of the kneeling angel, who reverently kisses the pale hands of the dead, crossed on her stiff, motionless breasts.'

The striking luminous contrast, the early Christian topic, and especially the latent eroticism associated with the young martyr – all this refer to Mandl's artistic role model, the Munich painter of Prague origin Gabriel von Max (1840–1915), whose work was consistently followed in Bohemia. The persuasiveness of Mandl's painting is based on the suggestive characterisation of a spiritual entity (the angel) or a spirit-imbued being (the saint) and the appropriate degree of erotic attraction between them; this is evoked by the long flowing hair of the young girl with a golden halo (resembling a diadem) and the angel kissing her hands clasped between her ample breasts. Like the figure in the painting *Soul (The Dug-over Grave)*, the spiritual entity of the angel in the canvas *Female Saint* is – except for the head and the right hand – a disembodied, glowing white apparition, distinct from the young martyr by its incorporeal form. We know that in the year in which he created *Female Saint*, Mandl travelled to Paris, where he may have been inspired by Carlos Schwabe or Alphonse Osbert, symbolist painters inclined towards the occult. This, however, did not stop him from decorating sacred interiors and depicting saints in a more traditional yet distinctive way, following the example of Maxmilián Pirner. In the same year, the stained-glass windows with the motifs of the country patron saints Wenceslas, Ludmila, Adalbert and Agnes in the chapel of the new municipal cemetery in Pilsen were made according to Mandl's sketches on cardboard. AF

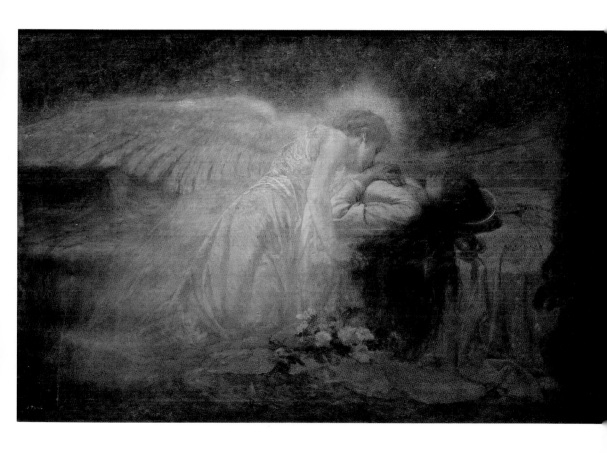

JOSEF MANDL
(Pilsen 1874–1933 Prague)

Ahasver, 1904

Oil on canvas, 73 × 129 cm

Inv. no. O 420

Acquired in 1962

Like his paintings *Soul (The Dug-over Grave)* and *Female Saint,* Mandl's *Ahasver* is a nocturne based on contrasting light and suppressing colour, death being the mutual topic in all of them. According to the biblical apocryphon, the 'Wandering Jew' or Ahasver, the shoemaker of Jerusalem, was condemned for taunting Jesus Christ on Golgotha to not die and, as an old man, to drag himself without relief all over the world until Christ's Second Coming. His kneeling figure, which is brought to the foreground in the painting thanks to the 'cropping', and thus into imaginary contact with the viewer, is reminiscent of the Baroque statue of the hermit Garinus in the so-called Bethlehem cave near Kuks in Bohemia by Matthias Bernard Braun. While Garinus directs his gaze towards the visitors, Ahasver turns his eyes heavenwards as he clasps his hands in a prayer to God. The painting's impressiveness stems from the existential emptiness of the indeterminate desert scenery; apart from the old man, there are only the remains of another figure – the reclining skeleton of the Grim Reaper with his scythe. The reproduction of the painting in *Zlatá Praha (Golden Prague)* magazine in 1904 was accompanied by a poetic commentary by the historian and critic Karel Boromejský Mádl, in which he described the emptiness as follows: 'There is no life left in the infinite wasteland and shadows. Everything has died; even Death itself has died. He lies over there, exhausted and limp [...].' It depicts the moment when Ahasver, upon seeing the skeletal figure of Death, realises that the consolation of death is not coming for a long time and, with remorse in his eyes, tries to convince the Lord to change his fate. The apocryphal story opened an unexpected view of death, and therefore was processed many times both in literature and visual arts, for example by Gustave Doré in his cycle of twelve woodcuts (1856), by Gabriel von Max in the painting *Ahasver at the Corpse of a Child* (1875), and by his pupil Carl von Marr in *The Secret of Life* (1878). The Prague painter Theodor Hilšer exhibited his *Ahasver* in 1889. While Max, Marr and Hilšer evoked a striking age contrast – an old man versus a child, a young girl or a pair of lovers – accompanied by a gesture of melancholy or mourning, Mandl focused on a weak, lonely man facing the power of eternity. AF

Karel Rašek
(Prague 1861–1918 Prague)

Fountain (Fairy Tale), 1910

Oil on canvas, 91.5 × 134 cm

Inv. no. O 1177

Purchased in 1987

At the turn of the twentieth century, fairy tales, which had been a popular liter-ary form for several decades in both European and Czech literature, became an important source of inspiration for Czech visual art. Fairy tales developed poetic imagination linked to the world of supernatural phenomena, provided an oppor-tunity to break away from the naturalism of the time and, at the same time, used the world of artistic imagination as a new platform for the further development of the emerging modern art. Karel Rašek's painting *Fountain (Fairy Tale)* belongs to this subject matter. In it, the artist depicted a mysterious scene taking place in a gorge surrounded by high rocks, where a large bird with a crown on its head and blue-green wings guards a water spring gushing from a fountain. Human skulls and bones are scattered around the fountain, and a rider on a white horse comes through the rock passage from behind. It is likely that Rašek was loosely inspired by the Brother Grimms' fairy tale 'Der Quillende Brunnen'. The spring is an important motif in the story, for when it dries up it is a sign of approaching death. However, the figure of the bird does not appear in the fairy tale and there-fore it is possible that Rašek based his depiction on several fairy tales. When the painting entered the collections of the Gallery of West Bohemia in Pilsen, it was listed there first under the title *Mythological Scene* and later as *Fairy Tale*, under which it was exhibited and reproduced. At present, however, this painting can be positively identified with the painting that Rašek exhibited at the time of its creation (1910) at the annual exhibition of the Krasoumná jednota (Fine Arts Association) in Prague's Rudolfinum under the title *Fountain*, i.e., with an obvious reference to the literary piece by the famous German writers. Rašek devoted himself intensively and consistently to fairy tale themes in his work. This was undoubtedly due to his several years of training at the Academy of Fine Arts in Prague under Maxmilián Pirner, who often used fairy tale motifs in his symbolist-oriented work. The painting is characterised by a dark tonality of colour, which enhances the sombre mood of the depicted story and, at the same time, refers to the Munich school of painting, which influenced Rašek during his studies in Munich after the mid-1880s. RM

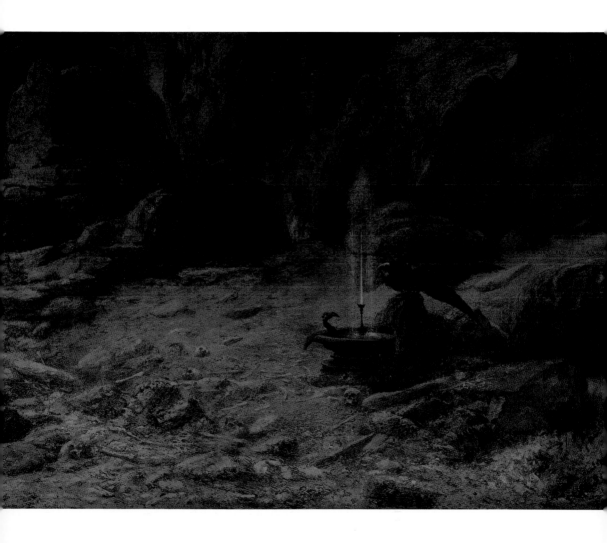

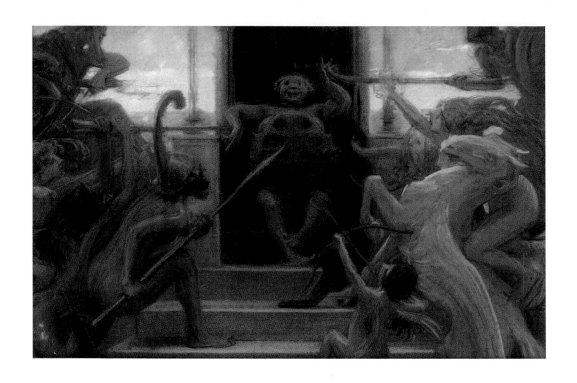

Maxmilián Pirner
(Sušice 1854–1924 Prague)

The Feast of the Frog King, 1895

Pastel on paper, 62 × 96 cm
Inv. no. K 975
Purchased in 1979

From the mid-1870s to the 1910s, Pirner's work unfolded against the backdrop
of complex artistic relations, emerging new movements and significant social
changes. During this period, his work underwent a developmental transforma-
tion in terms of painterly expression, and its distinctive content was infused
with new artistic styles – neo-romanticism, symbolism and art nouveau. Pirner
relied heavily on literary subjects, shifting towards allegorical, mythological,
fairy tale and mythical themes and often worked in entire cycles, usually in an
excellent pastel technique. Pirner's complex and introverted nature, as well as
his fear of unfavourable criticism, caused the painter to gradually close himself
off from the outside world in his studio, except for his tutoring activities as
a teacher of figurative painting (from 1896 he was a professor at the Academy
of Fine Arts in Prague). After the turn of the century, ornamental stylisation
took an increasingly important place in his work, treated in the peculiar style
of late art nouveau decorativeness, which became the stage for the dichotomy,
decadence, feelings of alienation and sarcastic commentary upon the 'out-
side' world. *The Feast of the Frog King* is a pictorial anecdote that develops
on the fairy tale themes that appeared even more frequently in Pirner's work
in the 1890s. In the scene where the frog sits on a throne wearing a tortoise
shell to ward off the attacks of the outside world, we can see an allegory of
contemporary society, where the situation – not only on the art scene – was
escalating. The painter reflected this in several works (for example, *The Peg-
asus Cycle*), in which he expressed his ironic attitude towards the turbulent
and ambivalent atmosphere of the time. In these works, Pirner often applied
grotesque deformations and strong, ornamentally shaped lines. His favourite
technique was pastel, which preserved the freshness of colours and allowed
the artist to draw in a very relaxed style, although it was extremely fragile
in larger formats. The painter rarely signed these pictorial grotesques as he
intended them for private use. ŠL

Hanuš Schwaiger
(Jindřichův Hradec 1854–1912 Prague)

The Pied Piper of Hamelin, 1909

Pencil and watercolour on paper, 33 × 21 cm

Inv. no. K 27

Acquired in 1954

Before Hanuš Schwaiger became a professor at the Academy of Fine Arts in Prague in 1902, he had mostly worked outside Prague. He lived in Austria and later in Moravia, where he settled in an abandoned gamekeeper's lodge near Bystřice pod Hostýnem. Despite living his life in seclusion, he was quite well known through exhibitions and art magazines, as well as through his work as an illustrator. He was interested in history, literature, fairy tales, fantasy and romantic stories, and strange creatures. He also found sources of inspiration in Romantic literature: the original German tale of the stranger who uses a magic pipe to rid the town of Hamelin of rats and, when the treacherous townspeople refuse to pay him, takes all their children away forever, was adapted by Goethe, the Brothers Grimm and Robert Browning. All the renditions have one thing in common: the Pied Piper is the counterpoint of mundaneness and bigotry and a symbol of fantasy, defining itself against the shallowness. *The Pied Piper of Hamelin* was Schwaiger's debut. He revisited this theme many times and it seems that the Pied Piper was a character with which he identified himself. The first Pied Piper, which he created during his studies at the Academy in 1879, takes the form of a six-part cycle of pen drawings and is the closest to the standard version of the tale. The watercolour *The Pied Piper* from the same year, now housed in the Albertina in Vienna, represents a peculiar rendering of the subject, depicting a bizarre man with rats under a courtyard gallery from which an old woman and her children look out. In this guise, as a grotesque figure in colourful clothes, both ridiculous and terrifying, the Pied Piper appears in several later versions, of which the one presented here is one of the last. In Schwaiger's concept, the Pied Piper hides under a variety of masks and disguises, communicates with the creatures of the night, commands the forces of nature, and takes the forms of a rogue, a piper and a sorcerer. That the author felt himself to be a similar rogue and outcast can be inferred from the fact that some of his Pied Piper characters bear self-portrait features. Schwaiger's distaste for the bourgeois society was probably behind this stylisation, embodied by his own family, with whom he did not get along very well. He claimed himself to be 'an indecent painter who became one against the will of his respectable family'. IS

JAROSLAV PANUŠKA
(Hořovice 1872–1958 Kochánov)

Interior with a Skull, c. 1900

Oil on cardboard, 46 × 71.5 cm
Inv. no. O 1339
Purchased in 1996

Jaroslav Panuška was undoubtedly one of the distinctive and original personalities of Julius Mařák's landscape studio at the Academy of Fine Arts in Prague in the 1890s. Before that, he had briefly attended the studio of Maxmilián Pirner. Pirner's influence can be seen in Panuška's depiction, at the turn of the century, of various fairy tale and otherworldly creatures, including water sprites, witches, ghosts, ghouls, demons, vampires, monsters, undead and other supernatural figures. It was for this aspect of his work that Panuška was greatly admired by the representatives of Czech decadence, grouped around the magazine *Moderní revue (Modern Revue)*, where he was especially praised by the poet and artist Karel Hlaváček. This period also includes the painting *Interior with a Skull*, which exists in several variants that Panuška created between the second half of the 1890s and the beginning of First World War. Today, they are presented under various titles (e.g. *Nocturne, Visit of the Dead, Dead Man Claims His Skull*). The subject of all the variants, which differ only in some minor details, is a scene taking place in an obscured study of a scholar (perhaps even a spiritualist), where a human skull is placed on a table with books, with a dead man's arm reaching through the window. The ghostly atmosphere is completed by sheets of paper stirred by the draught and an extinguished candle whose wick is still smoking. The skeleton of a human hand is depicted here as a fluid, unknown force from beyond the grave, as a nocturnal spectre and a juggernaut that has penetrated the world of the living, in whom it evokes terror and fear. The scene recalls a disturbing dream as a product of our subconscious, one of the characteristic aspects of Panuška's pieces from this period. On the other hand, we must perceive Panuška as an earthy, albeit educated man and a great storyteller with a sense of humour; moreover, he was a friend of the writer Jaroslav Hašek, who certainly did not consider himself decadent and approached subjects of this kind with a certain degree of irony. RM

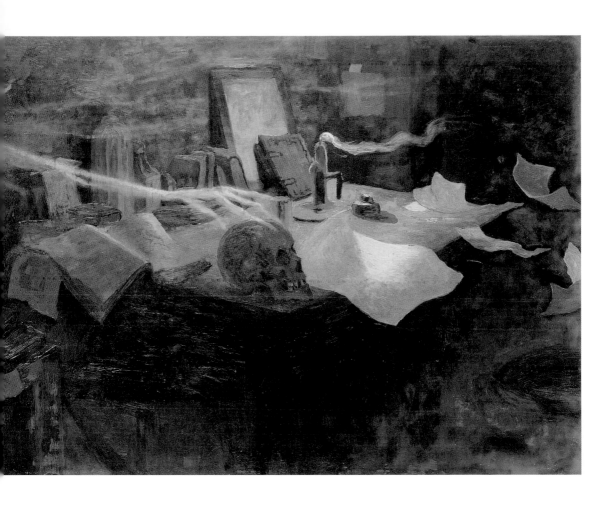

JAROSLAV PANUŠKA
(Hořovice 1872–1958 Kochánov)

Living Willows, 1905
Watercolour, India ink and gouache on paper, 50 × 60 cm
Inv. no. K 1118
Purchased in 1988

At the end of 1905, the publishing house of Bedřich Kočí in Prague published
a remarkable book by Václav Říha titled *Summer Night,* accompanied by sev-
eral colour and black and white drawings by Jaroslav Panuška. However, his
illustrations were not created to accompany the finished text, but the other way
round: Říha wrote the book based on Panuška's earlier drawings. *Summer Night*
is set in a poor mountainous region where the tradition of telling ghost stories
thrives, populated by all sorts of fairy tale and fantasy creatures that have become
a permanent part of the lives of the local inhabitants. The main message of the
story, then, is an attempt to draw attention to the disappearance of the unique
culture of the old world, which is slowly giving way to modern civilisation and
general progress. One of Panuška's colour drawings printed in this book is
entitled *Living Willows* and illustrates the story told by one of the villagers who
recounts a haunting experience during his journey home through the marshy
landscape. During his journey, he saw tiny musicians playing strange melodies
in the branches of the willows. The described scene eventually turns into an
almost surreal dream, featuring strange creatures, drowned people, monsters
and other supernatural beings that were after nothing less than the narrator's life.
In a colourful linear drawing, Panuška depicted willows, as if dancing to the
rhythm of the music of those little musicians, waving their elongated branches,
which have the shape of human hands and fingers. The central tree even has
a kind of head with an open mouth, which stands out against the open, gloomy
sky with a special expression. The tree branches refer to the tendril-like arms
of Panuška's numerous ghosts and undead, most of all to his gouache painting
The Stranded (1901). In it, the artist worked with a similar motif of an animated
tree whose branches reach for a fleeing, stranded female figure. Thanks to the
congenial harmony between the artist and the author of the text, currently the
book is considered a rare bibliophile edition and occupies an important place
in the history of Czech writing and illustration. RM

Jaroslav Panuška
(Hořovice 1872–1958 Kochánov)

Spectre, 1899

Charcoal on pale-brown paper, 34.5 × 22.5 cm

Inv. no. K 180

Acquired in 1954

Panuška's interest in fairy-tale themes, representing ghosts, water sprites, vampires, witches and other supernatural creatures, developed during his studies at the Academy of Fine Arts in Prague. The future artist spent only a year in Maxmilián Pirner's studio, but the professor's paintings full of mythological, fairy-tale and fantasy creatures in wondrous landscapes inspired and enhanced the young student's vivid imagination. Panuška's work around the turn of the century was also influenced by the contemporary interest in the occult sciences, spirituality and the study of the human psyche, including the subconscious and the darker aspects of the soul. The artist created impressive images of ghosts, spirits of the dead and strange apparitions, sometimes bordering on the grotesque, many of which were based on the imagination of rural people living in close connection with nature. At this time, Panuška was attracted to the work of Hanuš Schwaiger, a generation older, especially to his portrayal of the water sprite, a wild creature living between two worlds. In 1898, he revisited the motif of the water sprite several times in the form of a creature that had only a skull instead of a head, with massive teeth and bulging eyes that stare intently at the viewer. He developed this form in several variations in which the horrific face gradually changed. Today, we know them as *Apparition, Witch* and *Spectre.* The *Spectre* group includes several charcoal drawings, two of which are housed in the Gallery of West Bohemia in Pilsen. The work presented here depicts a creature whose human features are suppressed at the expense of large round eyes and massive teeth; its body is only hinted at. The spectre strains its eyeballs at its victim, literally hypnotising it; yet from its gaze and overall expression we feel uncertainty and anxiety rather than malice; the mouth, only slightly open, does not arouse fear; the creature is rather trying to hide. However, the reception of its expression, rendered in a masterful drawing, can be understood in many ways depending on the emotional state of each viewer. ŠL

JOSEF VÁCHAL
(Milavče, near Domažlice 1884–1969 Studeňany, near Jičín)

Head of Lamia, 1909

Stained wood, H. 33 cm
Inv. no. P 244
Purchased in 2002

Josef Váchal was a multi-faceted artist whose work spanned many creative fields. In the context of art nouveau symbolism, Váchal's early and still most appreciated work can be placed, among other things, in the ideological categories of occult and Christian mysticism. Váchal had an ambivalent relationship to occultism, characterised by both deep fascination and ironic scepticism. As a young man, Váchal was initiated into the secrets of theosophy and spiritualism by his father, with whom he had a complicated relationship as an illegitimate child. During his youth, Váchal acted as a medium, but terrifying visions of the afterlife haunted him even outside of spiritistic séances. His tensions were further fostered by his own work and by reading of occult, hermetic and demonological literature. He soon began to fight his fears and anxieties through sarcasm and irony, taking an ironic approach to his interest in ghosts, apparitions and demons. Based on his study of Baroque bestiaries and fictional Latin and German texts, Váchal developed his own demonology, which he most thoroughly elaborated on in 1924 in his book *The Devil's Garden,* or *The Natural History of Ghosts.* He parodied the prints whose authors, by categorising demons, assisted believers in their god-fearing defiance of the infernal forces. He himself, on the other hand, presented ghosts as beings who deserved protection from technocratic civilisation. In *The Devil's Garden,* Váchal also refers to Lamia, the demon who sucks blood and breaks the necks of all living things, by the names Kolduna neboli Phora campestra (Bedlam or Phora campestra) and Hubilka (She-killer). The wooden sculpture *Head of Lamia* dates to 1909, when Váchal began carving furniture for the writer Miloš Marten. As with painting, Váchal was self-taught in woodcarving. The *Head of Lamia* is a fanciful vision, raw and roughly rendered. The object is meant to be mounted on a wall; Váchal thus creates the illusion of a monster emerging from the wall, an incarnation of impending danger. MR

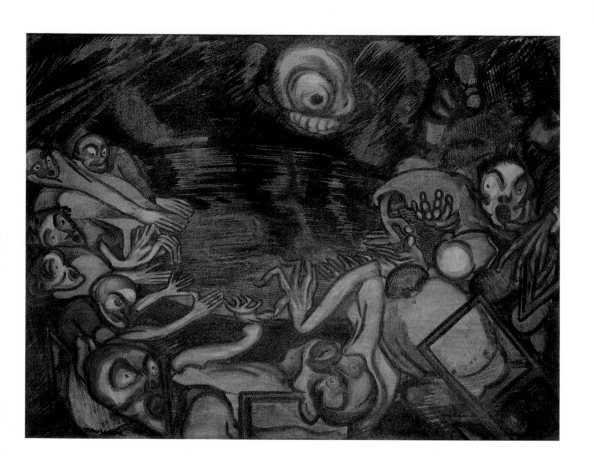

JOSEF VÁCHAL
(Milavče, near Domažlice 1884–1969 Studeňany, near Jičín)

Table-turners, around 1918

Mixed media on cardboard, 47 × 62 cm

Inv. no. O 1213

Purchased in 1988

The leaders of the spiritist movement, which spread in Europe and America from the mid-nineteenth century onwards, believed that under certain circumstances it was possible for individuals with extraordinary abilities (mediums) to contact the 'invisible realm of being'. This mysterious realm was identified by spiritists as the 'great beyond' – the space where the souls of the dead reside after leaving their physical shell and await a new incarnation. Josef Váchal's *Table-turners* are participants in a spiritistic séance. A materialised apparition, summoned by the spiritists from beyond the grave, hovers above the characteristic circle of hands joined over the top of the table. Váchal chose distorting perspective and expressive deformation to depict the event; however, he did not always connect ironic exaggeration with the motif of the séance. The concept of his favourite theme was often influenced by the generalised aesthetics of symbolism and neo-romanticism. He thematised the belief in the afterlife of the soul, as cultivated by spiritism, as a search for the possibility of the triumph of the spirit over the hated matter. Váchal had been firmly convinced since childhood of the existence of a space densely populated by beings of immaterial bodies and indeterminate states of matter, near the physical world. In his youth, he became acquainted with the teachings of theosophy, which viewed spiritism as an outdated stage of its own development. Nevertheless, the members of the Prague Theosophical Society experimented with spirit summoning in spiritistic séances. The spiritists' 'great beyond' corresponded to the 'lower astral plain' of the theosophists. After joining the Theosophical Society in 1903, Váchal participated in séances as a medium, among other things, and referred to this experience in his works. His undated work *Table-turners* was probably produced after his return from the First World War. It is closely related to another drawing from 1918, *Dream of the Dead,* from the collections of the Museum of Czech Literature, which too deals with the theme of the permeability of the physical world with the afterlife. MR

František Kupka
(Opočno 1871–1957 Puteaux)

Drawings from the L'Argent series for the magazine L'Assiette au Beurre, 1901

Unique in its concept, the satirical and socially critical magazine *L'Assiette au Beurre* began publication in Paris in 1901. Unlike other similarly oriented periodicals, it emphasised artistic expression and the texts only provided brief commentaries. Thematic issues, either collective or entrusted to a single artist, soon began to appear. The very name of the magazine, founded by Samuel Schwarz, shows the direction in which the social criticism presented in it was heading; loosely translated, it means the same as the 'pork barrel' in English. Given how difficult it is to characterise the political orientation of the magazine in unambiguous and precise terms, it was the criticism of existing social conditions that was the real common denominator. Many foreigners collaborated with the magazine, among them several artists from Bohemia. Many of those whose names are associated with modernist and avant-garde tendencies, such as Kees van Dongen, Jacques Villon, Juan Gris and Vojtěch Preissig, contributed to the magazine as well. They also included František Kupka, who made his mark in the history of art primarily with his concept of non-figurative painting. MT

L'Argent (Money)

In addition to his individual contributions, František Kupka produced three special issues for *L'Assiette au Beurre*, entitled *L'Argent* (*Money*, 1902), *Réligions* (*Religions*) and *La Paix* (*Peace*), both 1904. His attitudes, as revealed in his correspondence and especially in his writings, can be characterised as those of a freethinker. The subject matter of the three issues of *L'Assiette au Beurre* realised by Kupka seemed to correlate with these free-thinking inclinations. In the series *L'Argent*, to which the three drawings from the Gallery of West Bohemia in Pilsen belong, Kupka takes aim at economic profit with the central figure of pejoratively understood wealth – the biblical Mammon, to whom mankind is supposed to bow. Kupka portrayed it in the form of a monster with a belly filled with gold coins, in a modernised version of Monsieur Capital. The iconography of money is complex and, in the case of some artists at the time, certain anti-Semitic connotations can be observed. This is certainly not the case with Kupka, who was definitely not in the camp of the 'anti-Dreyfusards' who still represented a significant part of French public opinion at the time. Kupka's lifelong attitudes and friendships bear witness to this. MT

Frantlšek Kupka, *Balançoire que tout ça*, print of the final design in *L'Assiette au Beurre*, 1902, photo by Markéta Theinhardtová

František Kupka, *Les Sauveurs*, print of the final design in *L'Assiette au Beurre*, 1902, photo by Markéta Theinhardtová

František Kupka, *Liberté*, print of the final design in *L'Assiette au Beurre*, 1902, photo by Markéta Theinhardtová

Balançoires que tout ça (All That Is Just a See-saw),
a study for the L'Argent (Money) series, 1901

Chalk on paper, 41 × 32 cm

Inv. no. K 918

Purchased in 1971

The study for the fifth sheet of Kupka's booklet *L'Argent (Money)*, which appeared in no. 41 of *L'Assiette au Beurre* in January 1902, numbered by the author as no. 4, probably belongs to the first draft series of the overall project. Monsieur Capital – Mammon – amuses himself on a political seesaw, which he tilts according to which side his gold-filled belly will fare better. Currently, it is to the side of the Republic, represented by Mariana waving a Phrygian cap, while the monarchy is in decline. Unlike the dynamic proposal for *Liberté (Freedom)* from the same series, the sketch for *Balançoire que tout ça* is considerably more static and less explicit compared to the final realisation (see page 81). It does not use the bold view from below that Kupka applied to the final version to plant Mariana in the composition; we do not see the people cheering under the rising see-saw, nor do we see another representative of the monarchist regime, namely Napoleon I, who is forcefully clinging to the see-saw. This was an important historical allusion, which Kupka used in a later modern allegory for *L'Assiette au Beurre* in 1905, in which Free Thought, like an untamed Pegasus, throws down monks, kings, the emperor (Napoleon), but allows a judge to blindfold it in the end. The historically allusive support of the see-saw is missing in the sketch; it will turn into the ruins of the Vendôme Column in the following versions and the final print. The column itself was a symbol of the vicissitudes of history: modelled on Trajan's Column, it was intended to celebrate the victory of Napoleon I at the Battle of Austerlitz; after his defeat, the meaning of the column was modified in the sense of the restoration of the monarchy, only to be destroyed during the Commune and reconstructed again during the French Third Republic. Gustave Courbet was held responsible for the destruction of the Vendôme Column, imprisoned after the defeat of the Commune and eventually sentenced to pay for the damage. This allusive complexity of modern allegory is not evident in the sketch from the collections of the Gallery of West Bohemia, just as it lacks the dynamic formal element of curves in the background, referring to the phenomenon of historical time, compared to the final form. However, the design shows Kupka's operating mode and rapid refinement of the overall look. MT

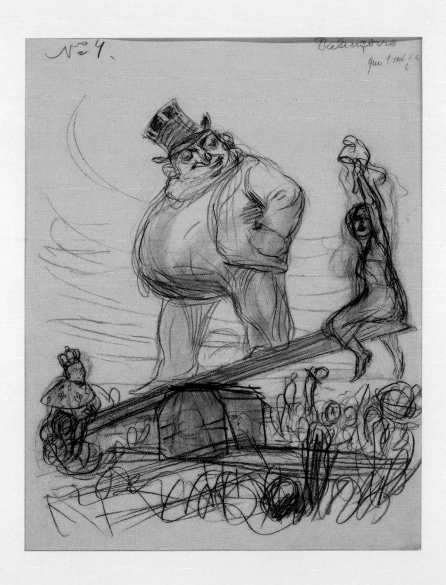

Liberté

Liberté (Freedom), a study for the L'Argent (Money) series, 1901

Pencil and chalk on paper, 41 × 32.5 cm

Inv. no. K 915

Purchased in 1971

In the study for the second sheet of the booklet *L'Argent (Money)*, published in issue no. 41 of *L'Assiette au Beurre* in January 1902, Monsieur Capital, a huge, omnipotent force with a belly full of gold – the biblical Mammon – 'protects' the social order with the help of troops, artillery and cavalry (visible in the final realisation on page 81), ready to attack. Towards the factories with smoking chimneys in the background, the working masses of people walk, their freedom (*liberté*) thus appearing precarious in the extreme. The number one designation might indicate the original intention to start the cycle with the slogan introduced in the Second French Republic: 'Liberté, Égalité, Fraternité' ('Freedom, Equality, Fraternity'). In the magazine reproduction, however, after the title page, the cycle is introduced by *Le Théâtre des Marionnettes (The Puppet Theatre)*, where Monsieur Capital is portrayed as an all-powerful political puppet master. This is followed by three full-page spreads bearing the titles of the individual parts of the slogan. The *L'Argent* cycle has its own logic and content: it shows situations of a specific political or general nature in which money plays a role in one way or another, whether in the form of the monster Mammon or Monsieur Capital with his top hat. The monster on the cover, wading in the blood of drowning men and difficult to fight with one's bare hands, turns out badly in the end – nailed to the shield of Pallas Athena, which through Science shows mankind the way to Humanitas (Humanity). It is not Revolution, then, but Science that will bring mankind to understanding itself. Artistically, the individual sheets of the cycle are connected by colour – a round belly full of money, or simply a yellow disc of golden sun, liquid gold or an explosion. Each of the sheets has its own specific structure, testifying to Kupka's mastery and transformation of the principles of traditional composition and allegorical narratives, applied to the contemporary situation. The design for the sheet *Liberté*, which lacks individual details that elaborate the narrative, clearly shows Kupka's formal language: the curve of the movement of the masses as a dynamic principle against the vertical static nature of the centre with the idol of money and its protectors. MT

Les Sauveurs (Rescuers), a study for the L'Argent (Money) series, 1901

Chalk and India ink on paper, 41.5 × 32.5 cm

Inv. no. K 927

Purchased in 1971

This drawing, numbered by the artist as no. 13, is a study for the tenth sheet of the booklet *L'Argent (Money)* for *L'Assiette au Beurre* of January 1902. It is also apparently part of the first design series of the overall project that Kupka submitted to the commissioner, although here, in contrast to the previous studies, ink dominates, adding urgency to the scene. The history of the path to the final form of this modern allegory hints at the possibility of a shift in meaning within the same allegorical figure and iconography. In 1900, Kupka published a scene entitled *Moderne Sklavenjagd (Modern Slave Hunt)* in the German-edited magazine *Das Album*, to which French cartoonists contributed. Innocence, unable to escape any further on a broken wooden bridge, is pursued by three grotesque male figures, led by a pot-bellied rich man with a top hat. In the study for *L'Assiette au Beurre* from the Gallery of West Bohemia in Pilsen, we encounter an interesting intermediate stage between the initial and final concept: Kupka has essentially preserved the scene but simplified it. Of the 'rescuers', a rich man with a top hat and two pouches of money has remained with two hearse drivers in the background. As in the drawing for *Das Album*, Innocence has no choice but to plunge into the abyss or be corrupted by money – a very dark way out, as the recurrent motif of smoking chimneys in the background suggests. The figure of Innocence in the Pilsen study, however, takes the same stance as in *Das Album*, depicting naivety in cartoonish exaggeration. In the final version (see page 81), Kupka altered the scene only in the sense that the rich man was transformed into Monsieur Capital with a belly full of gold coins. Innocence changed her attitude, becoming a *midinette* (a rather vacuous but fashion-conscious young woman, most often a naive country girl who moved into town and became embarrassed about her origin), which is emphasised by a round hat case, complete with a coquettish ribbon. This detail is crucial: the character of Innocence is aware of the hopelessness of her situation. Even given the then highly topical subject of the social status of women, but above all given the succinctness and lucidity of the message, *Les Sauveurs* is by all accounts one of the high points of socially critical graphic art of the fin de siècle. MT

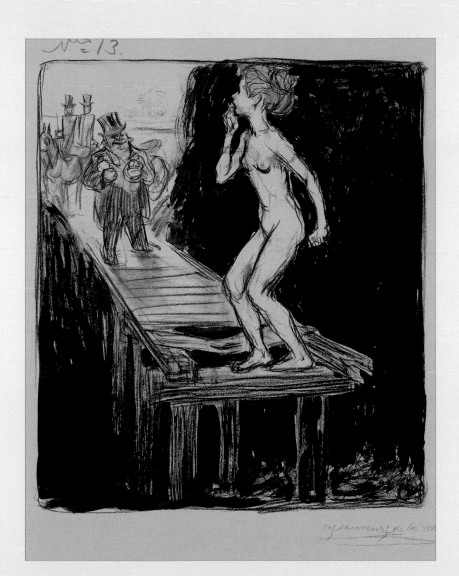

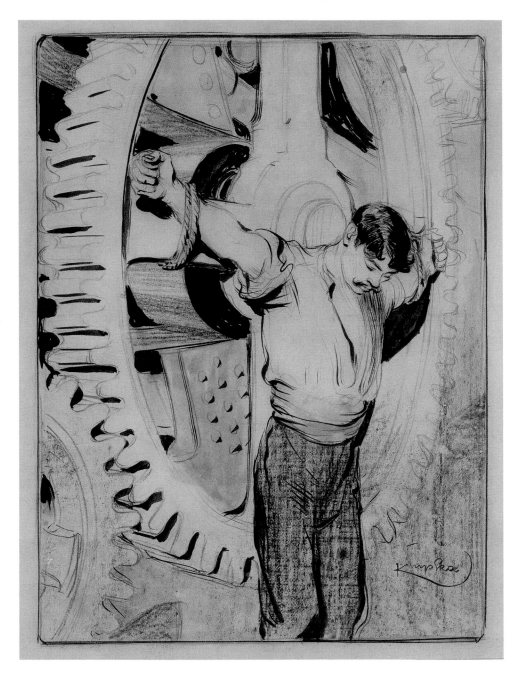

FRANTIŠEK KUPKA
(Opočno 1871–1957 Puteaux)

A Worker Crucified, 1901

Pencil, chalk, India ink, watercolour on paper, 31 × 22.5 cm

Inv. no. K 933

Purchased in 1972

František Kupka, who would later become known primarily as a pioneer of non-figurative painting, worked in the first years of the twentieth century in the cosmopolitan subversive environment of Montmartre mainly as a drawer, graphic artist and illustrator. In his numerous compositions published in magazines, he capitalised on his previous long academic training, but infused them with new concepts in the context of symbolism and social-critical satire. His drawing *A Worker Crucified* dates from 1901, when he also began working on the series *L'Argent (Money)* for the social-critical and satirical magazine *L'Assiette au Beurre.* Kupka first offered the *Worker* to the exhibition committee for the First Workers' Exhibition in Prague in 1902 as a possible model for a postcard. On that occasion, the Social-Democratic daily *Právo lidu (People's Right)* published a commentary on 25 July 1902, describing Kupka's Worker as 'a human being sacrificed by our blessed century of humanity'. In 1906, the Parisian anarchist weekly *Les Temps nouveaux (New Times)*, founded by Jean Graves, printed a black-and-white version of Kupka's drawing. Along with Kupka, some other artists who sympathised with the magazine, including Camille Pissarro, Paul Signac, Maximilien Luce and many others, provided their works free of charge and participated in its raffles. The magazine survived in a time of political, legal and financial uncertainty thanks to the tirelessness of its founder. Another version of the drawing (originally in Harald Szeemann's collection), which depicts an elderly worker with a stern expression on his face (most likely a portrait of Jean Grave), refers to this situation. On this occasion, it is possible to assume that the model for the worker's likeness could have been Kupka's friend, the Czech writer, poet and politician Josef Svatopluk Machar, who was linked to Kupka in those days by his free-thinking inclinations and whom the painter portrayed several times. The main motif of a worker tied to a factory wheel could be loosely inspired by Martin Gerlach's popular album *Allegorien. Neue Folge* from 1896, where Alfred Cossmann's sheet no. 73 *(Industry)* with a similar motif is printed. MT

ANTONÍN HUDEČEK
(Loucká, near Budyně nad Ohří 1872–1941 Častolovice)

Gleaners, 1899

Oil on canvas, 50 × 84 cm
Inv. no. O 1065
Purchased in 1982

Antonín Hudeček was one of the leading personalities in Czech art at the turn of the twentieth century. From 1887, he studied at the Prague Academy of Fine Arts in the studio of figural painting under Maxmilián Pirner, even though his interest from the beginning was directed more towards landscape painting. In the autumn of 1891 he went to Munich, where he enrolled in Anton Ažbe's private school, and the following year he attended Otto Seitz's studio at the Munich Academy. At the internationally attended Munich exhibitions, he soon gained an insight into the current artistic trends and new directions. After returning to Prague in 1893, Hudeček continued his studies under Václav Brožík, whose genre paintings from Brittany and Normandy resonated strongly in the Czech artistic circles. Inspired by the massive production of French realistic landscape and rural genre paintings, Brožík depicted rural people at work in the fields and at rest in countless variations. Hudeček turned to similar themes in the second half of the 1890s, but his artistic presentation, already influenced by modern trends, was quite different. He was intrigued by the figures of peasants during hard field work but, at the same time, he tested new artistic techniques and various colour and light solutions; in some of his works he reached a concept close to pointillism. In addition to the paintings *Picking Potatoes* (1896), *Reapers* (1897), *Ear Gleaner* (1899) and *In the Field* (1899), the oil painting from the Gallery of West Bohemia in Pilsen is another work from this series on working themes; it shows how the young artist tried out new possibilities of pictorial expression. His already technically advanced handwriting, based on working with a patch of colour, captured the impressive atmosphere of the moment with a great sense of colour and light; Hudeček created here an extraordinary harmony of tones, accentuated by the white scarves and aprons of the women. Their figures, rendered with the utmost veracity and quiet monumentality, completely focused on their work, are part of the landscape with which they form a perfect whole. Hudeček revisited these working themes in the late summer of 1902 during one of his stays at Okoř. ŠL

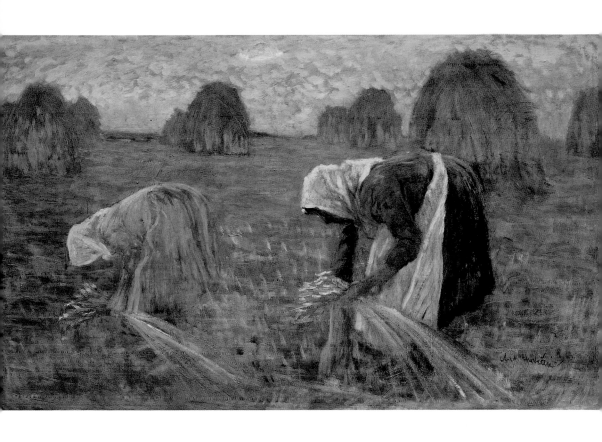

JAROSLAV ŠPILLAR
(Pilsen 1869–1917 Dobřany)

Forest / Fiesole, 1900

Oil on cardboard, 47 × 64 cm

Inv. no. O 915

Purchased in 1974

At the very beginning of 1900 Jaroslav Špillar spent three months in central Italy, where he visited three important cities in the region of Tuscany: Florence, Fiesole and Livorno. During his exploration of Florence, he stayed in nearby Fiesole, originally an ancient city with Etruscan heritage, characterised by a concentration of medieval and Renaissance monuments, as well as a remarkable history and an important commercial past. It was here that Giovanni Boccaccio set the plot of his world-famous collection of short stories *Decameron,* and it was in this town that numerous Florentines took refuge during the plague epidemic that struck the Tuscan capital in 1348. Špillar stayed here in Via Vecchia Fiesolana by invitation of his friend and admirer, the Swiss art critic based in France, William Ritter, who initiated his visit to Italy. In addition, Špillar's great artistic role model, the Swiss symbolist painter Arnold Böcklin, was living in Fiesole at the same time. During the time he spent there, Špillar produced several landscape studies, including *Forest / Fiesole.* The small town with olive groves, which sprawls on a hill above Florence, surrounded by pine and deciduous forests and tall cypress trees dominating the rolling landscape, must have been extremely attractive to the Czech artist. With the motif of a sunny forest interior with great views into its depths, Špillar drew on the popular works of Julius Mařák, the founder of modern Czech landscape painting. Špillar's painting, however, had already been abandoning excessive realistic details. The tree trunks are painted with long brushstrokes, a flat application of light-coloured thick paint, as is the green, grassy area at the edge of the forest. On closer inspection, this is a landscape from southern Europe, as dark and tall cypress trees flash through the forest and perhaps a hint of the urban agglomeration of Fiesole itself. A year after his Italian trip, Špillar exhibited most of these landscape studies at an exhibition in Prague. RM

Jaroslav Špillar
(Pilsen 1869–1917 Dobřany)

Thaw, 1902

Oil on canvas, 95 × 77 cm

Inv. no. O 916

Purchased in 1974

In the spring of 1902, Jaroslav Špillar and his family moved from Postřekov to Pec pod Čerchovem, a village located in the hilly and densely wooded region of Domažlice. Špillar built a villa with a studio there in the hope that he would find new inspiration for his work in this place. This was especially true of landscape painting, which was his focus at the time. Špillar was particularly attracted to winter landscapes; he wanted to depict them with the shared experience of a person working in direct contact with the frosty and snowy nature, i.e., directly in the open air, not just in a studio. For this purpose, he even had a small mobile studio on wheels built according to his own plans – a sort of smaller version of a caravan, with glass walls and a small stove inside. He then had it towed by horse to the place where he had found the best motif and where he worked in relative peace and comfort. The painting *Thaw* therefore probably dates from the time when he was getting used to his new home and chose themes from the surrounding area for his works. In it, Špillar depicts, at close range, the edge of a forest at the time of the changing seasons, with a stream flowing out of it, fed and strengthened by melting snow; the painter thus creates for the viewer an almost textbook case of composition according to the academic rules of the time. He makes perfect use of the light of the rising sun, which causes long, bluish shadows behind the first row of trees, and presents the unique atmosphere of a forest waking up to a new day. The exquisite work with light suggests that Špillar was familiar with the works of the French impressionists. In fact, he could see them in a representative selection at the 1900 World Exhibition in Paris, which he visited together with his brother Karel, also a painter. Jaroslav Špillar thus created a fully-fledged parallel to the work of the artists who emerged from Mařák's landscape studio at the Prague Academy of Fine Arts, to whose generation he belonged. RM

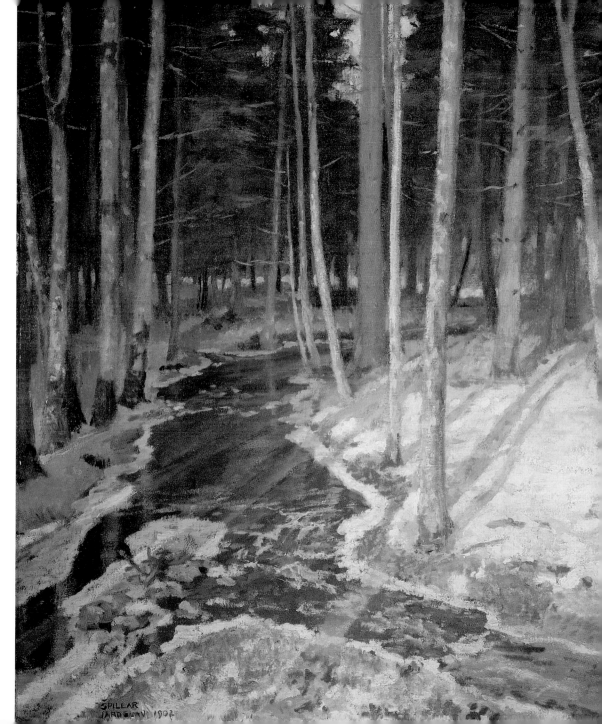

JAROSLAV ŠPILLAR
(Pilsen 1869–1917 Dobřany)

Winter Trail, 1903

Oil on canvas, 75 × 80 cm
Inv. no. O 305
Purchased in 1960

In his 1903 painting *Winter Trail,* Špillar used one of the many motifs provided by the winter landscape in the vicinity of the village Pec pod Čerchovem, which he could paint thanks to his mobile, glazed and heated 'studio on wheels' even at the coldest time of year. The artist chose for his painting a large feature of a forest trail in a snowy winter landscape, with tree trunks cropped at the upper edge of a square format. This format, which began to be used also in landscape painting, was made famous by Gustav Klimt and other protagonists of the Viennese art nouveau. In the Czech context it was favoured, apart from Špillar, by Antonín Slavíček during his 'Kameničky period' in the Bohemian-Moravian Highlands. Like Slavíček in some cases, Špillar worked here with the proportions of the golden ratio section. He divided the picture surface into three diagonal areas, the middle of which is the snow-covered winter trail, which crosses the canvas from corner to corner and adds a special dynamism to the composition. It is a painting with a monochromatic colour palette: the artist uses a rich range of shades of white to express the plasticity and different consistency of the snow cover, which is already compacted and thus somewhat dirty on the trail, and over which parts of dark tree trunks and protruding soil with roots dominate in contrast. In the Czech landscape painting of the time, this subject is atypical due to its minimalist concept, which the artist mastered with excellent painting technique. Špillar's elaborate painting with its many nuances of white colour can perhaps only be compared with the similarly brilliant work *The Snowy Owl* (1862) by Karel Purkyně, in which its creator tackled an identical painting problem, or with the winter landscapes of Špillar's contemporary František Kaván – who, however, depicted more open natural scenery. In the same year as the *Winter Trail*, the Society of Friends of Czech Science and Literature in Pilsen organised a large exhibition in the metropolis of West Bohemia which included almost all the previous representations of Špillar's œuvre, including landscape painting; however, the *Winter Trail* was not among them. Despite its absence, in the preface to the catalogue its author, philologist and ethnographer Jan František Hruška highlighted Špilar's genre works on the life of the Chod people and their ethnographic significance. RM

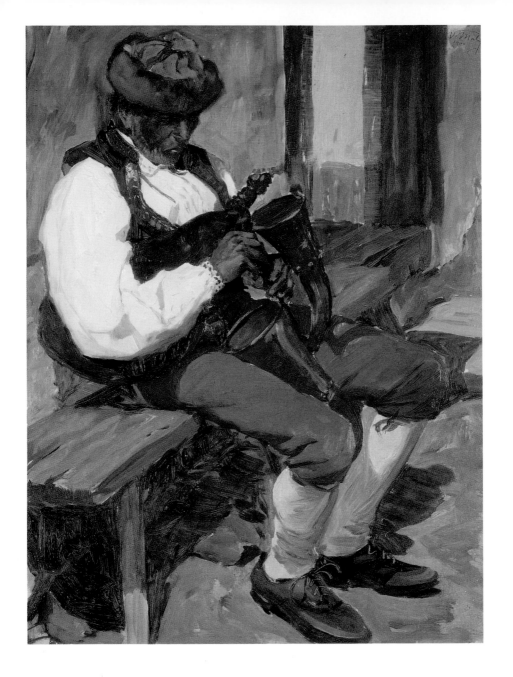

VÁCLAV MALÝ
(Prague 1874–1935 Prague)

Bagpiper from the Domažlice Region, 1908

Oil on cardboard, 48.5 × 36 cm

Inv. no. O 20

Acquired in 1954

The ethnographic genre in painting thrived in the 1890s, especially in connection with the Ethnographic Exhibition held in Prague in 1895. The journeys of folk painters often led to places where folk culture was still alive and local customs were preserved. In this respect, Moravian Slovakia was a promised land to them; among the Bohemian regions, the Plzeň and Chodland regions were characterised by their preserved folk traditions with their attractive, brightly coloured costumes, the charming landscape of the Upper Palatinate Forest and the Bohemian Forest, and the dramatic history of peasant rebellions popularised by Alois Jirásek's 1884 novel *Psohlavci (The Rangers)*. Jaroslav Špillar is the undisputed founder of the Chod genre in painting. He first lived in the Chod village of Postřekov; from there, he later moved with his family to Pec pod Čerchovem. Václav Malý, a graduate from the Academy of Fine Arts in Prague, is one of Špillar's followers: although in the early years of his work he dealt with Old Prague motifs, Malý soon turned his attention to Chodland and Moravian Slovakia. In Chodland, he painted landscapes, group scenes from rural life and individual persons. He also illustrated books by the Chod writers Jan Vrba and, especially, Jindřich Šimon Baar. Malý was known to the public primarily as the author of the covers of Baar's collected fiction, which were published in the 1920s and 1930s. His *Bagpiper from the Domažlice Region*, resting on a sunlit doorstep, is wearing a traditional Chod costume: yellow leather culottes, white stockings and black shoes, a white shirt with a blue embroidered waistcoat and the 'vydrovka' – a cap made of green velvet trimmed with otter fur. Malý's works focusing on Chod themes, painted with a broad brush, and capturing light and colour with remarkable subtlety, were successful at exhibitions abroad, a testament to the popularity of the ethnographic genre: for example, his *Sunday Morning on the Domažlice Square* (probably 1910) was reproduced and favourably reviewed in the London art magazine *The Studio* in connection with the review of the Vienna Hagenbund exhibition in the spring of 1910. IS

JAN PREISLER
(Popovice, near Beroun 1872–1918 Prague)

Spring (triptych), 1900

Oil on canvas, 112 × 70 cm, 112 × 186 cm, 112 × 70 cm

Inv. no. O 897

Purchased in 1973

The painter Jan Preisler, a graduate of the School of Arts, Architecture and Design (UMPRUM) in Prague under František Ženíšek, was a regular collaborator of the progressive architect Jan Kotěra. In 1898, the latter became a professor at UMPRUM and, at the same time, his first Prague design, the art nouveau Peterka's Department Store on Wenceslas Square, was accomplished. For its interior, Preisler painted the *Spring* triptych, the theme of which he had chosen himself. The spring landscape on the outskirts of a village is far from idyllic; the vitalistic content of the popular subject is problematic, which may be surprising in 1900, when art nouveau reached its peak of influence. The landscape with its low horizon feels cramped, the figures do not communicate with one another or, if they do, it must only be an internal, covert dialogue. Preisler delves into the feelings, imagination and daydreams of his hero, a melancholic youth turning into a young man. The realistically rendered figure of the sitting young man differs from the rather sketchy depiction of the three female figures embodying his fantasies, whose heads are embedded in the narrow layer of the cloudy sky. The two wings of the triptych with the sitting girls are distinguished by the painting technique, inspired by the syntheticism of Paul Gauguin, from the clear *valeur* painting of the central section, whose landscape is rendered in impressionistic broken colour. *Spring* met with extraordinary acclaim at its first presentation at the third exhibition of the Mánes Union of Visual Artists in the autumn of 1900. Preisler was able to interpret the new content of 'spiritual painting' in a modern painterly form that enhanced its effect: the triptych became

the first painting of his peak period and a programmatic work of the
emerging young generation. In conceiving his favourite subject of the
figure in the landscape, Preisler was influenced by a range of painters
from the Pre-Raphaelites, Giovanni Segantini and Fernand Khnopff to
Ludwig von Hofmann and the landscape painters of Worpswede; yet, even
in a European context, his work is distinctive and original. AF

JAN PREISLER
(Popovice, near Beroun 1872–1918 Prague)

Seduction / Temptation, 1901–1902

Oil on cardboard, 50.5 × 40.5 cm

Inv. no. O 613

Purchased in 1965

In 1901–02, Jan Preisler painted several studies in charcoal, pastel and oil, which later became known under the title *Seduction.* It depicts a man pressing himself to the limp body of a girl, who submits to him with her arm loose. The scene is watched impassively by three other young females sitting on the grass. This series of works was created in continuation of Preisler's pastel drawing, printed as a 'dedication sheet' in the magazine *Volné směry (Free Directions)* in 1901, dedicated to Jan Neruda. The drawing depicts a huge figure of the Greek god Pan, who is holding the lifeless body of a girl, resembling a puppet, in his hands. Another girl's body rests discarded on the ground next to Pan. This scene has an accompaniment like the *Seduction,* which consists of three sitting female figures whose eyes are fixed on the main scene and whose gestures even encourage Pan in his actions. In the painting *Seduction,* Preisler endowed the male protagonist with undisputable dominance which he exerts over the girl by force. As with the 'dedication sheet', this scene suggests a kind of ritual in which one of the girls is sacrificed to satisfy the man's desire. Again, the girl is depicted as a soulless puppet who responds to the act of seduction with passivity. Preisler never succeeded in bringing the subject to a final artistic form, and the version from the Gallery of West Bohemia was only presented to the public for the first time at the Mánes Union of Visual Artists exhibition at the Municipal House in Prague, ten years after the artist's death. It is questionable whether the title, which does not fully correspond to the depicted scene, originated from the artist himself or was assigned to the work ex-post. *Seduction / Temptation* has been painted with darkened colours, which even led art historian Antonín Matějček to speculate that an unforeseen chemical reaction of the white paint had occurred over time, causing it to darken. In any case, this is a unique work in Preisler's œuvre, as it lacks the typical lyrical dreaminess, harmony of relationships and spiritual kinship that the artist applied, especially in his works with the theme of loving couples. RM

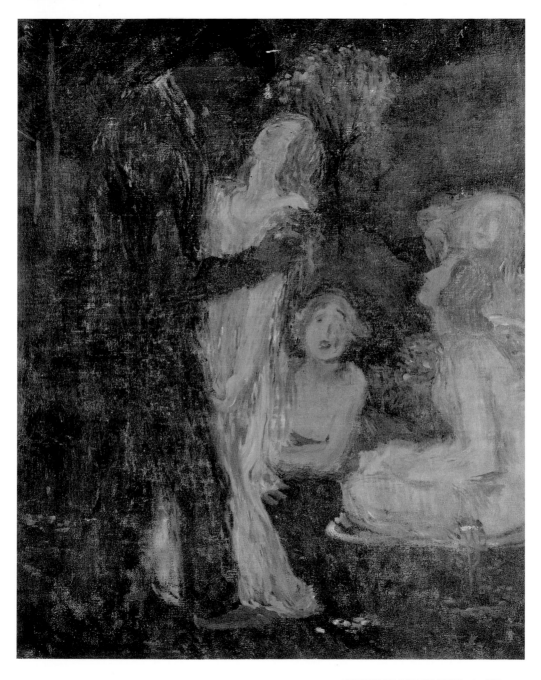

JAN PREISLER
(Popovice, near Beroun 1872–1918 Prague)

Young Man by the Lake, 1903–1904

Oil on canvas, 44 × 53 cm

Inv. no. O 869

Purchased in 1972

Preisler created the painting *Young Man by the Lake* at a time when he was concentrating on his key work, *Black Lake*, which was preceded by a series of studies and variant solutions. The present painting is specifically related to a vignette by Preisler, intended as a header image for James MacNeil Whistler's lecture 'Ten O'Clock', published in the magazine *Volné směry (Free Directions)* in 1904, which became a kind of forerunner of the *Black Lake*. One of the studies for this vignette (which was not published in the end) depicts a young man leaning against a rock beneath a tree, gazing at the dark surface of the lake. This was the basic thematic and compositional concept that Preisler further developed in the presented painting. The picture is painted as if from an elevated point of view, in large patches of colour that levitate in space, and it is no longer entirely clear what exactly they depict – whether the surface of the water, rocks, sky or land. The only thing that is visually recognisable in the painting and has relatively identifiable features is a tree with a round crown, and the seated figure of a young man leaning over a black lake. It is probably one of Preisler's most abstract works, an indication of the similarly constructed space of landscapes in Josef Šíma's paintings, which the latter created from the late 1920s onwards and which earned him the position of one of the most prominent representatives of Czech interwar modernism. With its psychological atmosphere, the displayed painting refers to the states of the human soul, affected by sorrows and tribulations, i.e., themes that Preisler dealt with in his work at that time. The lonely and huddled figure of the young man, enclosed among the formations of rocks and water, also evokes strong feelings of existential despondency. The depiction of the archetypal landscape can also be understood as a sophisticated backdrop that is part of a gloomy, almost surreal dream – a product of the young man's subconscious – and at the same time it also suggests a narcissistic aspect as he gazes into the water's surface, which may not only mirror his physical form, but also show a reflection of his aching soul. This is a work quite exceptional in Preisler's œuvre, even though it remained only in the form of this study, which was not completed by the artist in its final form. RM

ANTONÍN HUDEČEK
(Loucká, near Budyně nad Ohří 1872–1941 Častolovice)

Landscape with a Stream, 1900

Pastel on cardboard, 70 × 104 cm
Inv. no. K 980
Purchased in 1981

Antonín Hudeček studied at the Prague Academy of Fine Arts in the studio of
Václav Brožík from the autumn of 1893. During the longer periods when he was
away in Paris, Brožík used to transfer his students to the landscape studio of
Julius Mařák. There, Hudeček became close to Mařák's pupils Antonín Slavíček,
Otakar Lebeda and many others, and in 1897–1902 he regularly went with them,
already as a graduate from the Academy, on summer excursions to Okoř Castle.
The picturesque landscape with the village along the Zákolanský brook, a pond
and a medieval ruin, which attracted the attention of Romantic painters and poets,
became – in its various light and atmospheric transformations – the subject of
their landscape works. In addition to the company of the artist he had befriended,
Hudeček was attracted to working *en plein air*; his intimate, mood-reflecting
landscapes were influenced by symbolism with literary connotations, while at
the same time coming to terms with modern European movements, especially
impressionism. From 1898, Hudeček began to use colour patches in his paintings
and in the following years, also influenced by foreign role models, he perfected this
technique. He was particularly interested in the light effects both on the open and
tree-shaded water surface, which led him to a distinctive concept of pointillism.
The effect of mirroring is also explored in *Landscape with a Stream*, which shows
Hudeček as a focused observer who is unusually sensitive to the colours of nature,
as well as its melancholic and nostalgic tones, which he is able to interpret using
modern artistic techniques. Pastel, a technique which he began using alongside
oil and watercolour around 1900, left the work brightly coloured and enabled the
artist to express the synthesis of light and air in the landscape. Hudeček's works
from this period were very accurately characterised by Jaromír Pečírka in *Prager
Presse* in 1924 in a review of his jubilee exhibition: 'The essence of Hudeček's art
lies precisely in the spiritual and poetic content of his landscapes. It is only when
observing his works that the magnitude and sublimity of nature – the divine in
it – becomes clear to the viewer.' ŠL

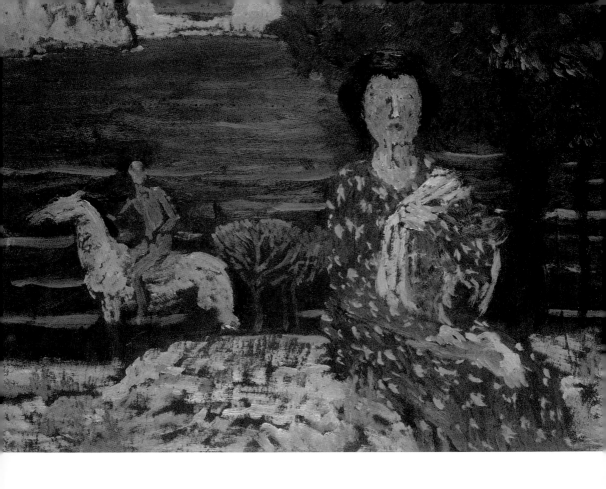

JAN PREISLER
(Popovice, near Beroun 1872–1918 Prague)

The Woman and the Rider / Black Lake (study), 1905

Oil on cardboard, 30 × 40 cm
Inv. no. O 923
Purchased in 1974

In 1905, Jan Preisler began work on his painting *The Woman and the Rider*, in which he further developed the motif of his previous key work, the *Black Lake*. The new painting was preceded by several studies, one of which is in the collection of the Gallery of West Bohemia in Pilsen. A young, naked rider on a white horse, standing by a black body of water, looks from afar at a sitting female figure in a distinctive dress, who fixes her gaze directly on the viewer. The seemingly calm scene creates a special tension by the impenetrability of the plot and the meaning of the work, which are only hinted at by the artist with some references from the field of mythology and Christian symbolism. The white horse is a symbol of life and metaphysical forces, or a mediator between the earthly world and the great beyond; the woman, with her emotionless expression, resembles the sphinx; the citrus tree can be understood as the tree of knowledge. The whole scene breathes a prevailing atmosphere of sadness and melancholy. Moreover, the surface of the black water is an archetypal and Freudian symbol of the human unconscious obscuring the reality of the scene, which takes place on the verge of a dream or only the imagination in the mind of one of the characters. Interestingly, in the final version of the painting, there is a striking similarity in the faces of the young rider and the mature woman, which may indicate their closer relationship and may lead to the consideration of the artist's attempt to depict the counterpoint phases of human life. The Mediterranean character of the landscape with its sandy ground and white cliffs, which he used in the painting, stems probably from Preisler's personal experiences during his travels to the Mediterranean. Preisler was a representative of a new type of modern panel painting in the Czech context after 1900, which paved the way for intimate symbolism that resonated with contemporary Czech poets including Antonín Sova, Otokar Březina and Julius Zeyer. Preisler's work, however, also corresponded with the works of some of the innovative personalities of European painting, such as Paul Gauguin and especially Edvard Munch, whom Preisler helped to realise his first independent and extremely influential exhibition in Prague in 1905. Perhaps influenced by the Norwegian artist, Preisler's paintings abound in a more expressive colour palette than had been typical of his work before their encounter, as was pointed out by contemporary critics. RM

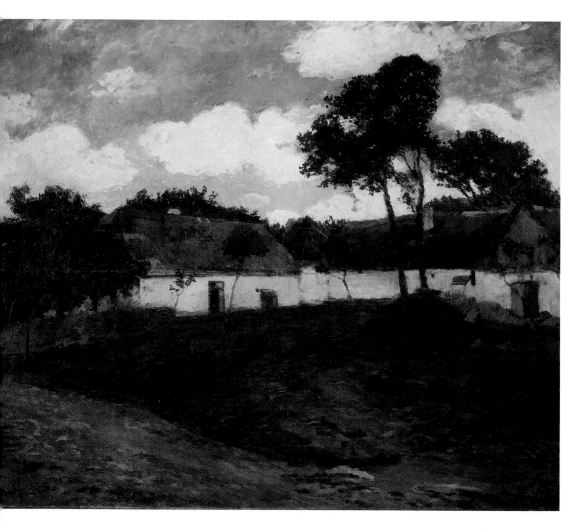

ANTONÍN SLAVÍČEK
(Prague 1870–1910 Prague)

Village Square in Příkrákov II, 1903

Oil on canvas, 117 × 136 cm

Inv. no. O 562

Purchased in 1964

Antonín Slavíček is one of the most prominent Czech landscape painters and probably the best-known representative of the Mařák's School, comprising graduates of Julius Mařák's studio of landscape painting at Prague's Academy of Fine Arts. Slavíček was considered the most talented landscape artist of his generation by contemporary artists and critics. He was Mařák's undisputed successor, yet after his teacher's death he was not placed at the head of the studio at the Academy, treatment perceived by the entire Czech art scene as unfair. The painting *Village Square in Příkrákov II* marks the beginning of an important period in Slavíček's work associated with the Bohemian-Moravian Highlands. In 1903–05, Slavíček realised his ambitious plan to create a modern, monumentalised image of the Czech landscape. This programme is most closely associated with the village of Kameničky; however, before he found a place for his regular summer stays there, he settled in the village of Střítež at the beginning of the summer of 1903. He then painted several paintings in nearby Příkrákov, depicting the village square there. The painter Antonín Hudeček, who came there to visit his friend Slavíček, also worked on the same subject. *Village Square in Příkrákov II* from the collection of the Gallery of West Bohemia in Pilsen is the largest work of the series. Slavíček created an even smaller version (now in a private collection) and a now lost one in pastel. In the painting from the Pilsen collection, the artist paid no attention to compositional details or description of what he saw; on the contrary, he attempted to capture the essence of the landscape as a whole and to unify the picture surface. He did not hesitate to manipulate the reality he saw in his efforts to simplify and integrate the composition. A comparison of Slavíček's works with Hudeček's painting shows that Slavíček omitted and relocated parts of the actual landscape scene in accordance with the needs of composition. This tendency was related to the will to exempt, synthesise and monumentalise the landscape image. It culminated a year later in Slavíček's large-scale works from Kameničky, especially in the famous painting *At Kameničky.* MR

Antonín Slavíček
(Prague 1870–1910 Prague)

The Road / Kameničky Scenery, 1903–1904

Oil on canvas, 116 × 136 cm

Inv. no. O 682

Purchased in 1967

Antonín Slavíček came to Kameničky in 1903 with the intention of creating a land-scape concept based on the poor and harsh Bohemian-Moravian Highlands that would contain something typically national, something that would be the proto-type of 'Czechness' (Miloš Jiránek called his friend and fellow Slavíček a 'fanatic of his native soil'). It is clear from Slavíček's letters from 1903–04 that he closely linked his programme of a national landscape with his desire for stylishness. The formulation of Slavíček's intentions was also aided by literature – he discovered Kameničky for himself thanks to the novel *Západ (Sunset)* by the Czech patriotic writer Karel Václav Rais, first published in 1899. The painting *Road / Kameničky Scenery* belongs to a group of works that Slavíček realised from the autumn of 1903 to the summer of 1904, in which he diligently and purposefully fulfilled the programme of a great landscape style synthesis. We can begin the list of works of the whole group with the unfinished painting *Motif from Kameničky* (1903) from the National Gallery in Prague, to which the large-scale painting *Road* is imme-diately related. In the present painting from the collection of the Gallery of West Bohemia in Pilsen, Slavíček developed and advanced his efforts to depict the poor and austere landscape of Bohemian-Moravian Highlands in the simplest and most concise forms. Other related paintings, *The Mountain Road* and *Mountain Motifs*, both in the National Gallery, also have generous scale. All the above-mentioned works present the viewer with an identical scene – Slavíček painted them in front of the cottage where he and his family stayed in Kameničky. In the painting *At Kameničky*, he summarised the partial views of the previous paintings of the series into a whole, deliberately monumentalising the landscape motif. In all the paintings in this series, he reduced plasticity with large surfaces and harmonised the austerity of the scenes with a clear linear outline. These means were of a highly symbolic nature: they were meant to convey Slavíček's strong impression of a land of sadness, austerity and hopelessness. MR

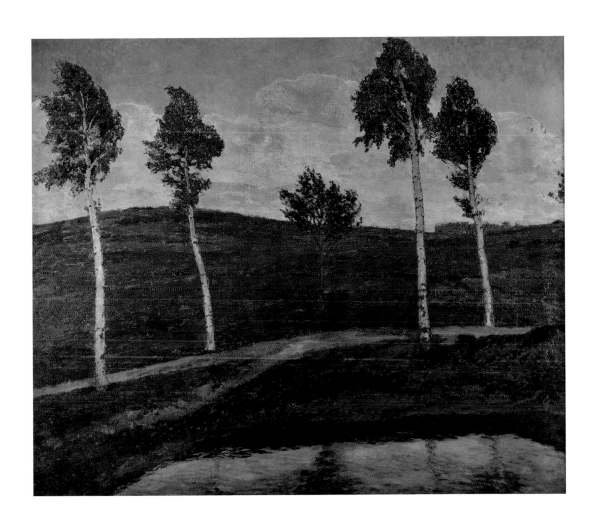

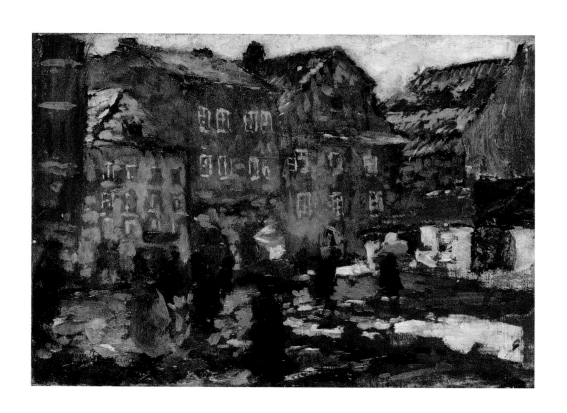

Antonín Slavíček
(Prague 1870–1910 Prague)

Mariánské Square (study), 1906

Oil on wood, 19.8 × 29.3 cm

Inv. no. O 991

Purchased in 1978

Antonín Slavíček began to devote himself systematically to the theme of Prague squares, streets and embankments in 1902. He usually painted in the city during the autumn and winter months, because in spring and summer he and his family stayed in various places in the Czech countryside. Therefore, Slavíček's Prague scenes are characterised by cloudy weather and a dark, melancholic atmosphere. Another common feature of his Prague works is the painter's interest in the old boroughs, disappearing one by one owing to the municipal redevelopment. Like other intellectuals, Slavíček was also bothered by the insensitive demolition of Prague's old nooks. He temporarily set up a studio near the old Jewish Town Hall and recorded some of the disappearing streets and houses in his paintings. His *Mariánské Square* also depicts the process of demolition. The work from the collection of the Gallery of West Bohemia in Pilsen is a study for a large painting now housed in the National Gallery in Prague. Both scenes show the inhabitants of the town walking around the square, avoiding mud and snow. The space is enclosed on one side only by a line of houses, the right part of the study and the final image is bordered by a makeshift fence with scraps of posters. Behind it, the demolition of one of the old Prague houses is probably underway. Slavíček also focuses on such mundane details as the shop signboards and the green kiosk in the middle of the square. He also spontaneously and casually records the silhouettes of pedestrians with umbrellas. The dark smudges of the figures are balanced by the occasional accents of colour in shades of red, green and blue. The painter here harmonises the colours masterfully but leaves the overall mood dark. Even though we feel echoes of melancholy in *Mariánské Square*, Slavíček does not drown in it; on the contrary, he depicts the scene unsentimentally, with attention being paid to the subtle manifestations of modernity. In his paintings of Prague, he explored the nascent metropolis in an unemotional manner, with no historical or literary connotations. MR

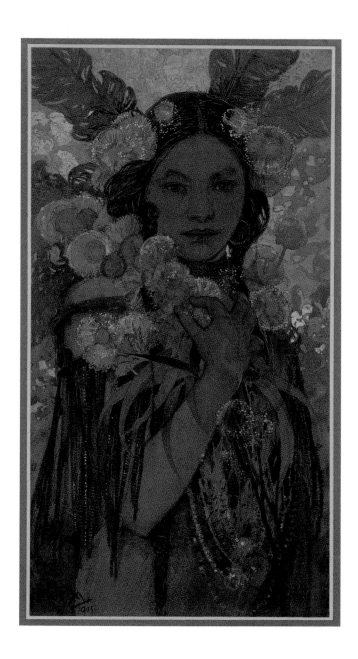

Alfons (Alphonse) Mucha
(Ivančice 1860–1939 Prague)

Native American Woman with Blossoms and Feathers, 1905

Pencil, watercolour and tempera on cardboard, 33.3 × 63.3 cm

Inv. no. K 309

Acquired in 1954

In the spring of 1904, Mucha made his first trip to the United States, where he returned repeatedly and finally settled for a long period of time. His decision to move to the United States was fuelled by the hope of higher earnings, which he intended to achieve as a portrait painter, so that he could then devote himself undisturbed to 'meaningful' work, which he saw in creating artworks with patriotic content; he tried to avoid the decorative commissions that had established his reputation. However, portraying high society ladies did not yield as much as he had expected, and his main source of income eventually became lectures at art schools. From the autumn of 1905, he ran his 'Cours Mucha' under the banner of the New York School of Applied Design for Women. His classes were very popular – and expensive. For the sake of teaching, Mucha was interested, among other things, in Native American artefacts, which he studied at museums and used as material in his lectures. According to the artist's son Jiří (George), very few things have survived from Mucha's American sojourn – except for a few portraits. One of them is a decorative panel titled *Native American Woman with Blossoms and Feathers*. It bears all the hallmarks of Mucha's style: a graceful girl with exotic decorations (flowers and bird feathers) entwined in her hair, gazing intently at the viewer. Jiří Mucha also quotes his father's letter, which reveals that he was preparing several panels with 'typical American figures' for his first American exhibition at the National Arts Club in New York in April 1906. One of these panels was apparently the *Native American Woman* from the collection of the Gallery of West Bohemia in Pilsen. A drawing of a Sioux chief from 1908 is also in the family's possession, and a figure of another Native American also appeared on a poster for the 1904 World Exhibition in Saint Louis. Mucha is also said to have thought of a Native American cycle that would combine the Native American myths and the history of the Moravian Brethren in the USA. Mucha's Native American theme is not unique in Czech art – note, for example, Mikoláš Aleš and his cycle *Elements,* in which he mourns the fate of the Native Americans and the unfortunate role Europeans played in it. Also, in another cycle from Slavic antiquity which Aleš made for the National Theatre, *Homeland,* we can find several motifs based on his reflections on the similarity in the respective fates of Slavs and Native Americans. IS

Alfons (Alphonse) Mucha
(Ivančice 1860–1939 Prague)

Portrait of a Girl, 1913

Oil on canvas, 47 × 46 cm
Inv. no. O 647
Purchased in 1966

The charming girl's face with hair wrapped up in a black scarf belongs to a series of small-format oil paintings that Mucha created simultaneously with *The Slav Epic* in the 1910s and 1920s. They depict girls and women in an ideal Slavic clothing – a white robe invented by Mucha – and were created either as studies for the *Epic*, or as depictions of figures from Slavic mythology and various allegories; some of them were created purely as a tribute to the beauty of the Slavic type. The figures depicted are no longer the lightly hand-drawn chic beauties of Mucha's Parisian period, but rather the wise priestesses of old gods. *The Slav Epic*, a cycle of twenty large canvases devoted to the history and apotheosis of the Czechs and other Slav nations, which Mucha had long dreamed of and whose realisation was made possible only by the financial support of the American entrepreneur Charles Crane, represented for the fervently patriotic artist the fulfilment of his ideas about an artist's mission and service to a nation. He did not consider his previous work as a decorative designer, which had brought him success and made his name known throughout the world, to be important for this mission. According to him, only *The Slav Epic* was to become the truly meaningful work of his lifetime, as it corresponded to the ideals of history painting. Mucha strove for an accurate knowledge of the time and environment he intended to depict and prepared himself thoroughly for the work: he read history books, consulted historians, made detailed studies of clothing, weapons and faces, and went on study trips to Russia, the Balkans and Greece, where he studied the rural people, their customs and costumes, which he considered close to those of the Old Slavs. In 1910 he began the work, to which he intended to devote all his efforts in the years to come. He and his family moved to the castle in Zbiroh, in whose large hall he was able to place the giant canvases. In 1928, the finished *Epic* was exhibited at the Trade Fair Palace in Prague, but it did not meet with a positive reception (unlike later in the United States). With the outbreak of the First World War, the world changed and the *Epic*'s message lost its relevance. IS

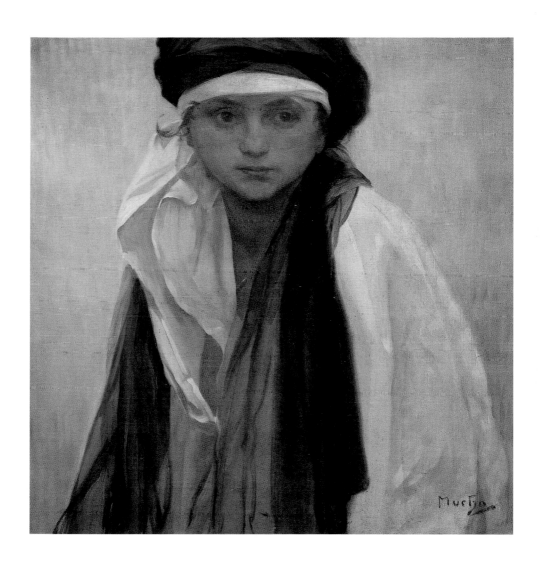

This edition © Scala Arts & Heritage Publishers Ltd, 2023
Text and photographs © The Gallery of West Bohemia in Pilsen, 2023

First edition published in 2023 by
Scala Arts & Heritage Publishers Ltd
305 Access House
141–157 Acre Lane
London SW2 5UA, UK
www.scalapublishers.com

In association with the Gallery of West Bohemia in Pilsen
Pražská 13
301 00 Pilsen, Czech Republic
www.zpc-galerie.cz

ISBN: 978-1-78551-435-7

Project managers: Bethany Holmes (Scala) and Tomáš Hausner (GWB)
Editor: Roman Musil
The authors of the respective entries are marked by an abbreviation at the end of each entry:
Aleš Filip (AF), Šárka Leubnerová (ŠL), Roman Musil (RM), Alena Pomajzlová (AP),
Marie Rakušanová (MR), Ivana Skálová (IS), Markéta Theinhardtová (MT)
Translation: Tomáš Hausner and Connaire Haggan
Language editing: First Edition Translations Ltd, Cambridge
Graphic design: Bušek & Dienstbier
Photography and reproduction: © ADAGP, Paris, 2022 (81, 83, 84, 87, 88); © Alamy Stock
Photo (6); © Malwina Antoniszczak (16); © Archives of the National Gallery in Prague
(9, 15); © Markéta Theinhardtová (81); The Museum of Decorative Arts in Prague (5);
© The Gallery of West Bohemia in Pilsen (19, 21, 25, 26, 29, 31, 32, 37, 38, 41, 43, 48, 50, 55,
59, 64–65, 66, 68, 70–71, 72, 75, 78, 83, 84, 87, 88, 91, 92, 95, 96, 98, 100–101, 103, 104, 107, 108,
110, 113, 114, 116 / Karel Kocourek: 34, 61, 62, / Oto Palán: 2–3, 22, 44, 47, 53, 56, 77, 119);
© The Museum of West Bohemia in Pilsen (Ivana Michnerová: 12)
Printed in Turkey

10 9 8 7 6 5 4 3 2 1

All rights reserved. No part of this book may be reproduced, stored in a retrieval
system or transmitted in any form or by any means, electronic, mechanical,
photocopying, recording or otherwise, without the written permission of the
Gallery of West Bohemia in Pilsen and Scala Arts & Heritage Publishers Ltd.

FRONT COVER:
JAROSLAV ŠPILLAR,
By the Moonlight, 1898

PP. 2–3:
EMANUEL KRESCENC LIŠKA,
The Dawn after Good Friday, 1903

BACK COVER:
ANTONÍN SLAVÍČEK,
The Road / Kameničky Scenery,
1903–04